DOODLES UNLEASHED

MIXED-MEDIA TECHNIQUES FOR DOODLING, MARK-MAKING, & LETTERING,

TRACI BAUTISTA

NORTH LIGHT BOOKS

CINCINNATI, OHIO

CONTENTS

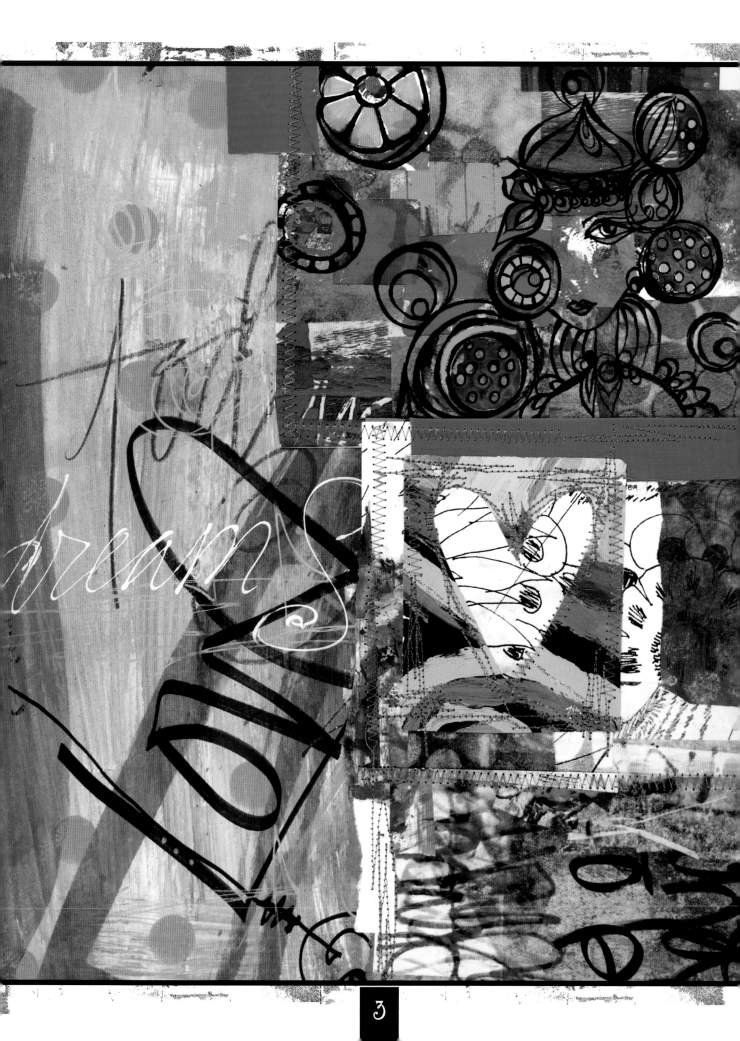

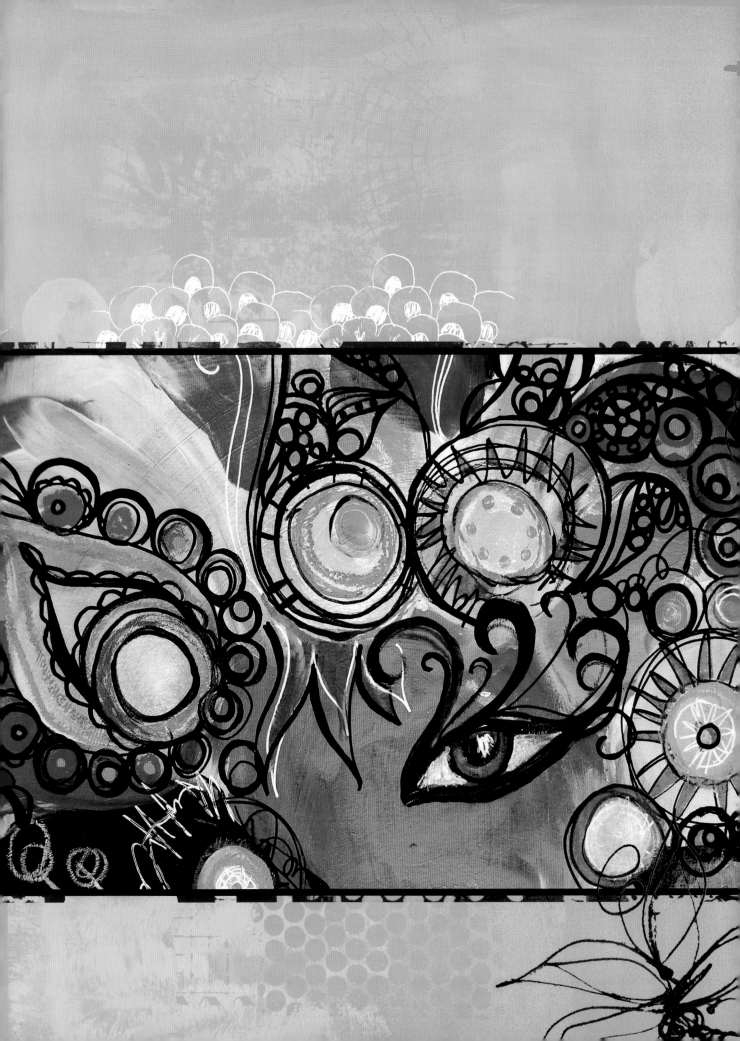

Doodling is an artform that many of us have practiced since we were young, whether intentionally or subconsciously. We all have our own artistic style, and it is displayed very clearly in the marks we make. For me, doodling is a time to make marks, experiment with lines and shapes and let them take over the page. Doodling is my form of meditation. As I work, it takes me to a place of relaxation and comfort. I don't plan out what I am drawing; the pen dances on the page as I let my intuition take over. Each mark leads to the next, and the result is never exactly what I expected. I never double-think or question the marks I'm making, but rather I let the marks spill onto the page. It's a fluid motion, unfolding over the canvas without a plan—total freedom.

My hope is to inspire you to create your own style of doodling, one that is completely distinct from anyone else's. It's easy to be influenced by other people's art, but making your own marks is essential to growing as an artist. I will provide you samples of my art and inspirational anecdotes to guide you toward creating your own signature style.

Throughout *Doodles Unleashed,* I share numerous photos, ideas, links to online content and images that will hopefully inspire you to find your own doodling style. The Creative Exercises and Jumpstarts are meant to be mixed in whatever fashion you'd like. There is no particular order to work in; skim through the book and open to a page that inspires you. Choose an exercise and be open to play!

I hope that through these exercises, you discover what doodling means to you and how to incorporate it into your art, life, journals and everyday creativity. Whether you devote ten minutes or an hour, doodling can be a great exercise to get your creative juices flowing. Grab some paint, paper, adhesive and pens and have fun with the exercises. Keep experimenting and striving to find your style. There is no right or wrong way to doodle; just pick up a pen and start making marks.

Visit my website, www.treicdesigns.com, for additional inspiration, digital downloads and online workshops.

Live artfully,
traci

HANDMADE AND FOUND MATERIALS

My favorite supplies encompass a wide variety of store-bought, handmade and found materials. I often experiment to discover unique ways to use everyday items in my artwork. I don't think you have to spend a fortune on supplies in order to make your own mark.

Handmade and found tools can be inexpensive and fun. It's the hunt for the objects that is part of the fun. Look at objects with different eyes; what can you use to make marks? Take a trip to the dollar store, hardware store or thrift shop, or look around your home. You'll be amazed by the simple tools you'll find and things that have alternative uses for stamping and printing. Train your eyes to see patterns and find textures in household items and found objects.

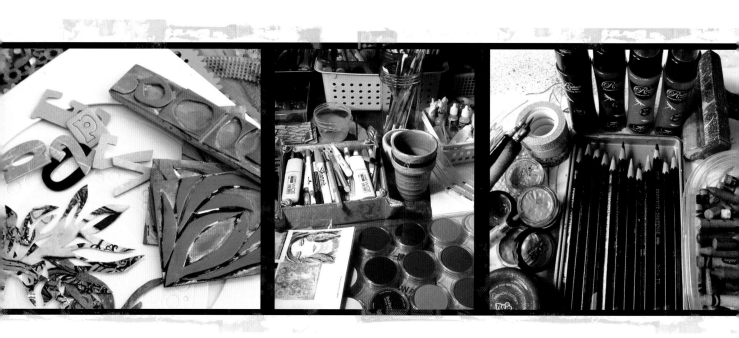

PAPER

I use a collection of found papers for my paintings and collages. I recycle brown grocery bags, construction paper, storybook newsprint, ledger and graph paper, manila folders, watercolor paper, and cardboard. I also use heavy drawing paper, copy paper, newsprint, maps, mailing envelopes, black paper and Asian newspapers for my journal pages. I bind most of these papers inside my art journals and stain and paint them with color. Even before I start doodling on the page, something is there—a mark, a color, a line—that inspires my doodles. I also use a lot of repurposed black-and-white photocopies of my original artwork.

STAMPS AND STENCILS

I make most of my stamps by either hand-carving them from rubber or cutting them from craft foam and inscribing them with a hot tool or a bamboo skewer. I also collect interesting items that I can use to make patterns, such as lasercut cardstock, paper diecuts, silk flowers and leaves, needlepoint canvas, textured wallpaper, sequin waste and drafting templates. I love letters and typography, so I collect letter stencils and incorporate them into my painted pages. A recurring theme in my mark-making is circles, so I often use empty thread spools, circular needlepoint canvas, binder rings, buttons, bobbins, coasters, the tops and bottoms of paint bottles, jar caps and plastic water bottles as stamps.

Throughout my travels I'm on the hunt for cultural patterns I can use for stencils, like the shadow puppet I discovered in Bali or the straw flower shapes I found at a craft store in Mexico.

ADHESIVE

My adhesive of choice is Collage Pauge. As for other adhesive tools, I use colored masking tape, washi tape, permanent roller adhesive and staples. I also create handmade stickers by printing my artwork on labels.

PAINTS AND PAINTBRUSHES

My paints of choice are acrylics and watercolors. My paintbrushes are simple. I mostly use 1" (2.5cm) foam brushes for background painting and to apply paint to stamps. For more detailed brush work, I use size 00 or 000 round paintbrushes, bamboo sumi brushes or inexpensive craft brushes. I also collect anything that can be dipped into ink to make marks with, such as bamboo skewers and coffee stirrers. I can't live without a soft rubber brayer; it's great for making prints, smoothing out collage elements and laying down large areas of color.

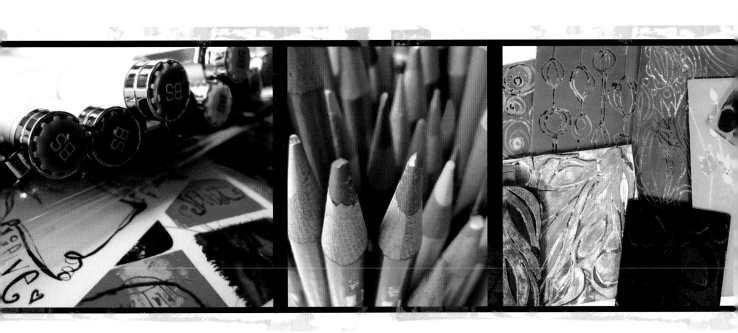

MARKERS AND PENS

I can't talk about doodling without mentioning markers and pens! I collect mark-making tools in all forms: from permanent paint pens and illustration markers to gel pens, colored pencils, oil pastels, soft pastels, oil paint sticks, calligraphy nibs and fabric markers. In my opinion, nothing is off limits when it comes to drawing!

UNUSUAL MARK-MAKING AND CALLIGRAPHY TOOLS

Besides paintbrushes, I use a variety of items to draw lines and make marks when I paint. I transform everyday objects, such as skewers, feathers and chopsticks, into painting tools. These are great to use with India ink, acrylic ink or watercolors. I also collect items like toothpicks, coffee stir sticks, craft sticks and utensils and bind them together with rubber bands; I then use the bound items as one big "brush." Craft sticks can also be altered by cutting and shaping the tips with a file to different angles. I save all of my hotel room keys, as these make great tools for scraping through paint. Palette knives, plastic pipettes, plastic dental syringes and stamp moistener applicator pens are other great unusual tools that will make your marks unique. I use a variety of calligraphy nibs; my favorites are the finger nib dip pen and the wide parallel pen.

DOLLAR STORE TOOLS

Dollar stores contain a myriad of interesting tools. I scour the aisles for multiple items that I can use to manipulate paint, such as hair combs, toothbrushes and crocheted doilies. I love rubber bands because they come in various shapes and are great for making organic, circular shapes. Another one of my favorite finds is foam hair rollers. The foam rollers print fun circles and the plastic closures create great backgrounds when paint is sprayed through them. Take a trip down each aisle to find more interesting tools like bubble wands and plastic spatulas.

THRIFT, ANTIQUE AND HARDWARE STORE FINDS

Spending an afternoon hunting for finds in a thrift store or flea market is sure to be a fun-filled day

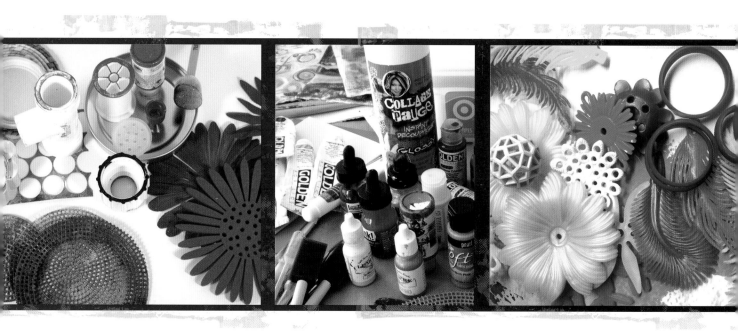

of discovering items that can double as painting tools. Seek out vintage plastic jewelry, woodtype letters, alphabet stickers and sewing tools. All of these can be used as stamps or stencils.

The hardware store is a treasure trove of goodies for painting and art making. From paintbrushes to PVC pipe to washers and rings, I find a plethora of items to inspire my mark-making. Hardware stores carry large canvas dropcloths that can be used to cover your work surface. Rosin paper is a great surface to paint on and can be found in the painting aisle. Painting rags are great for cleaning brushes or making fabric books.

WATCH IT!

GO TO WWW.CREATEMIXEDMEDIA.COM/ DOODLES-PLATES TO WATCH A VIDEO TUTORIAL ON HOW TO MAKE YOUR OWN DOODLE PRINTING PLATES.

HANDMADE DOODLE PRINTING PLATES

Create doodle printing plates by burning designs into craft foam with a hot tool that has various interchangeable nibs. Work in a well-ventilated area or wear a mask when creating the plates. As an alternative, inscribe designs into craft foam with a wooden skewer.

To use the plates, roll paint onto a piece of Plexiglas with a soft rubber brayer; this will help create an even coat of paint on the brayer. Roll the brayer over the foam printing plate to transfer the paint. Turn the plate over onto your chosen paper and press it to take an impression. This makes a great background paper to use for collage.

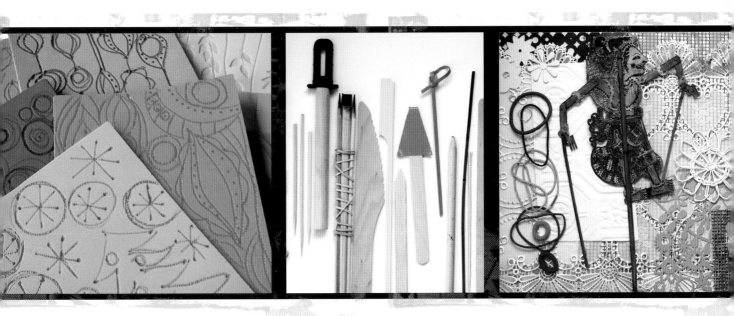

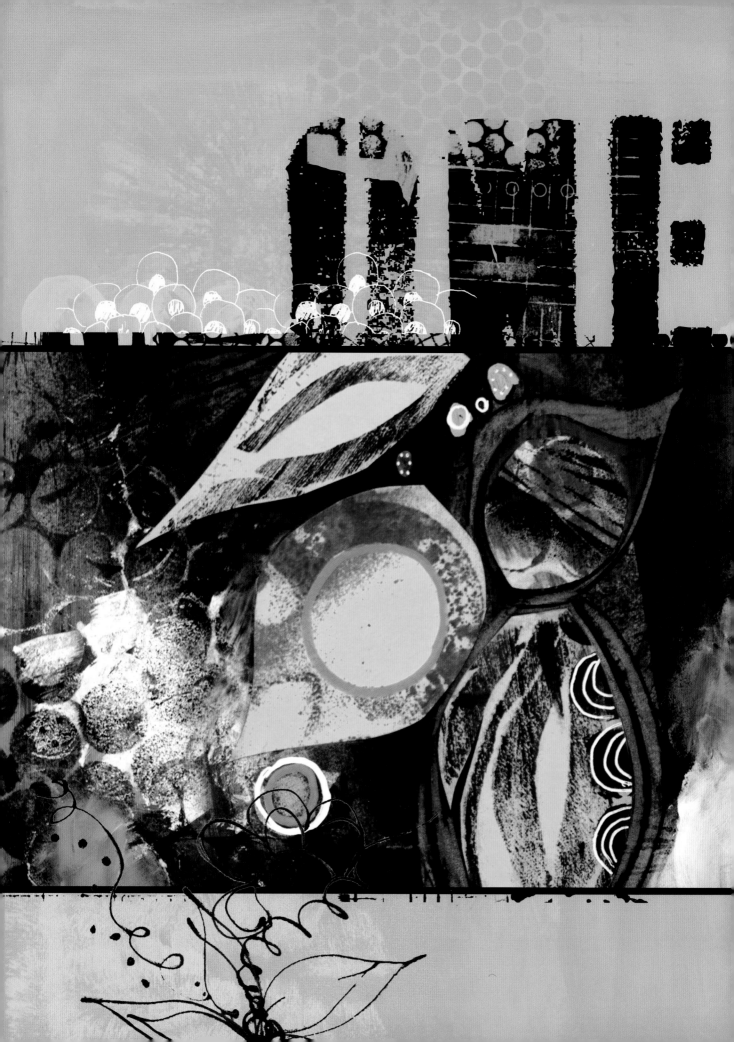

the reflection of the sky in the window ... a field of poppy pods ... a brushstroke of paint ... a drop of ink from a wooden skewer ... a photograph that captures the contrast of the tree shapes against the sunset ... a bouquet of tropical flora ... all of these things spark my imagination and inspire my creativity ...

Inspiration comes in many forms. You can discover it while traveling through an exotic land, inspecting the lines carved in cement sidewalks, having afternoon tea in your garden, looking at a colorful graffiti wall or rummaging through a reclaimed vintage store. Everyone's sources of inspiration are different. My inspiration is ignited by colorful patterns, letterforms, urban graffiti and the beauty of nature. Recording these inspirations helps guide my paintings.

lines and colors I want to accentuate. Training your eyes to look at pages or paintings in different ways will help you find the doodle. What shapes do you see in the background? What lines can you draw to call out certain areas of the page? Is the marriage of colors and papers creating the shape of a bird? Putting pen to paper is the easy part, but deciding where to go next, and what movement of the pen or tool should come next, is a more challenging task. Using photographs,

DOODLE INSPIRATION

Collecting inspiration in file folders and on boards creates a reference for my painted creations. I like to gather paint chips, photographs, fabric and paper swatches, magazine images, and embellishments to help jumpstart my projects. These inspiration collections are my guide through the creative process. Snippets of colors, text and lines are drawn from the pieces I collect.

Sometimes, my source of inspiration is a background that I have painted or collaged. I examine the painted page to seek out shapes,

fabric patterns and typography as jumpstarts for inspiration will influence the shapes, lines and colors of your own marks.

In this chapter, we will find our sources of inspiration and use them to explore the process of painting intuitively and drawing freely. We will learn to look for shapes and imagine the art that can spring from them. What do you see when you turn the painting in different directions? A face? An animal? A flower? Let your imagination soar to reveal the doodles.

DOODLE JUMPSTARTS

FIVE-MINUTE DOODLE EXERCISES

Take a few minutes to jumpstart your doodles with simple prompts. These exercises will help you overcome the blank page. Have fun and experiment!

DOODLE PROMPTS

Start with a few black markers in different weights. Use the following prompts to make a quick five-minute doodle:

1. Draw circles.
2. Draw floral shapes.
3. Change pens.
4. Draw lines.
5. Draw dots.
6. Connect the dots.
7. Fill shapes with patterns.
8. Draw lines.
9. Draw wavy lines.
10. Draw squares.

 IDEA: Explore variations of these prompts with different pens and markers.

CIRCLES WITH INK AND PAINT

Draw a circle on bark paper with a brush and fuchsia ink. Paint circles over the color with a brush dipped in India ink. Work quickly, without interruption.

LETTER DOODLES

Write thoughts or phrases onto the page without lifting your pen. Draw circles, swirls or wavy lines that extend from each letter. Write backwards. Alternate lowercase and uppercase letters.

Write the above prompts onto a piece of paper and cut them out. Put them in a jar or box. Select a prompt at random and follow it. When finished, place it back in the container. Repeat this for five minutes. You can also add your own prompts or ask others to give you prompts and add them to the jar.

CREATIVE EXERCISE
CREATE A JUMPSTART JAR

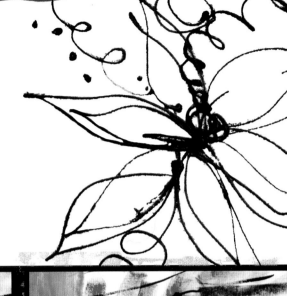

Tip

All of these exercises can be done on both paper and fabric. Experiment! Most of the art I make on fabric is for art journals, so it won't be washed. If you are making something that will be wearable, be sure to use textile paints and markers so your design is permanent.

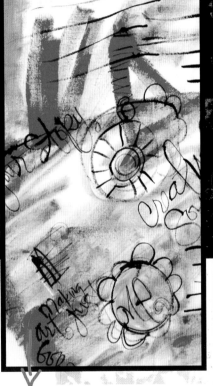

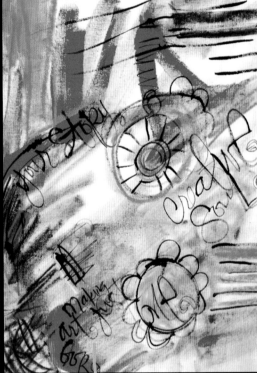

DOODLE SHAPES

Using a black permanent marker, practice drawing various shapes and lines together to create a pattern. This example shows teardrops, swirls and circles repeated in various ways to form a design.

BLIND DOODLES

Close your eyes and scribble and paint on a piece of muslin, alternating marker colors. This is a great exercise for creating spontaneous marks. Continue to build on your marks by adding more doodles with ink and a brush.

Open your eyes. Choose a couple of contrasting oil pastel colors to accent some of the previous marks. Write words. This piece makes a great background for journaling. You can also cut it up to sew an art quilt.

overcoming the blank page

Sometimes there are days when you face the blank page and ask, "What's next?" When this happens, try jumpstarting your creativity with these quick exercises. You can also add them to your jumpstart jar (see page 12). Suddenly, your page isn't blank anymore!

- Drizzle two to three colors of paint and scrape them across the surface.
- Paint random marks with a foam brush. Let them dry. Draw lines over the painted surface with a black chisel-tip permanent marker.
- Scribble phrases or words in crayon.
- Draw lines and doodles with a white correction fluid pen.
- Place letter stencils on your surface and spray paint on the page.
- Scan a picture or one of your paintings and print it out. Cut the scanned paper into random pieces and collage it onto the blank page.

Create a daily log of inspirations using these easy exercises:

- Collect photos and cut out shapes. Paste these into your journal.

- Flip through magazines and look for interesting advertisements and typefaces that you like. Add these to your journal as well.

- Use www.flickr.com to create a photo gallery of inspirations. Collect an image a day from online image searches.

- Create an account on www.pinterest. com to share your collection of inspiration links.

CREATIVE EXERCISE
DAILY DOODLE INSPIRATIONS

DOODLE INSPIRATION RESEARCH

When starting a new project, create an adjective bank of interesting ideas, words and phrases about your chosen theme, such as the flora and fauna theme shown at right. Feel free to draw shapes and doodles from photos you've researched, as well as other sources of inspiration. You can use these doodles to create a piece of artwork.

For the piece below, I created a background on a piece of muslin printed with a dyed paper towel, chipboard letter stencils and painted washes. Then, using my flora and fauna themed doodles, I painted a flourish with a paintbrush and white acrylic paint thinned with a little water and stamped a circle pattern with foam building blocks and turquoise fabric paint.

Dye paper towels using Colorations Liquid Watercolor mixed with a little fluid acrylic paint or Tulip fabric sprays. You can dip dye them, paint them with a brush or spray through a stencil. (Learn about the dyed paper towel technique in *Collage Unleashed*.)

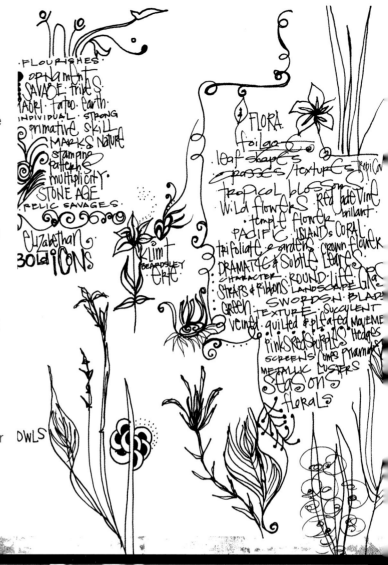

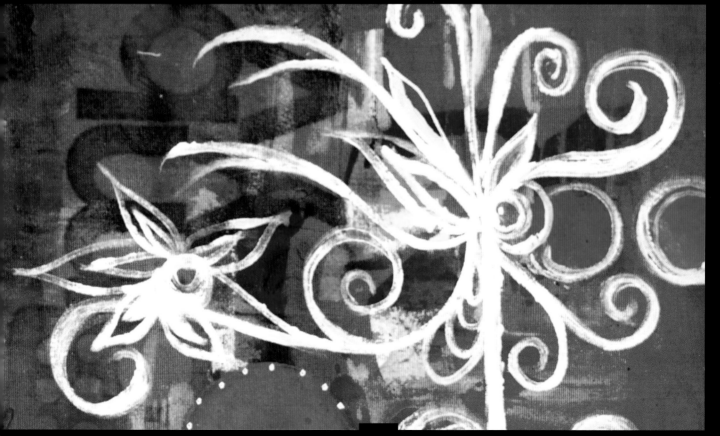

SPONTANEOUS MARKS

Spontaneous marks arise from a natural impulse: the movement of your paintbrush, a feeling or an emotion. I may be inspired by music, a photo, a color or a painting tool. These marks happen without thinking and are completely serendipitous. One mark leads to the next, and I keep going until the page is filled with color, never second-guessing my movements. Work rapidly and don't think too much. Create truly spontaneous marks by giving yourself permission to play!

Here are some ideas to try:
- Place various stencils on your chosen surface, then spray paint through them.
- Scribble marks and words as they come to you with dimensional paint.
- Paint through sequin waste and doodle over the resulting pattern.
- Call out areas of a painting with different pens and oil pastels, choosing your mediums at random.
- Stamp the entire alphabet onto a page and doodle about a word or theme that arises from each letter.
- Close your eyes and paint.

There is no right or wrong way to complete these exercises. Experiment with the ideas and mix and match the techniques to create your art. If you are ever stumped about what to do next, grab an idea from your jumpstart jar (see page 12). If you feel like you are adding too much to one page, it's time to move to the next one. Work on several pages at once to keep your ideas fresh. This will teach you to work spontaneously and freely.

 IDEA: Make marks to music. Turn on your favorite music and paint or draw lines inspired by the sounds you hear. If the music is fast and loud, translate that into your marks. Let the music be your muse.

FINGERPAINTING

Time to get messy and fingerpaint! Stamp patterns onto a canvas with multiple acrylic paint colors. Then dip your fingers into different paint colors, as well as white paint, and blend them on the canvas.

Tip

To successfully build layers in your paintings, allow each layer of paint to dry before adding the next mark. I work on five to seven pieces at a time, which allows me to let layers dry completely.

GRAFFITI ON CANVAS

Try painting on large pieces of muslin, drill cloth or canvas by spraying and painting the bottom layer, then gradually adding more spontaneous marks. Be sure to move the canvas as you work, turning it in different directions.

ORGANIC STAMPING

You can use all of your supplies to create unique pieces of art. Use a "cleanup" paper as your base. Stamp patterns with painted silk flowers and the bottom of a paint bottle to make large dots of paint.

RANDOM BRUSH MARKS

Paint random brush marks onto a surface. Then use a permanent marker to draw some shapes, such as circles and flowers. Continue to build marks and add color.

FINDING THE DOODLE

What do you see when you look at a painted background? It is so exciting to discover a doodle just waiting to be drawn. Study one of your painted backgrounds and try to see it with new eyes. I often see faces in my painted backgrounds, but there are so many other possibilities: flowers, birds, animals, trees and leaves. Your goal is to look at a page and visualize a doodle based on the colors, subtle lines and shapes suggested by paint or collage. Once you find the doodle, focus on pulling out interesting shapes and lines using a variety of mark-making tools.

Collage painted papers onto a surface. Let the colors and shapes on the page inspire your mark-making. What do you see? A face? An animal? A flower? Choose a few markers, pens and pencils and begin pulling out the shapes and lines that you see. Turn the page in a different direction, make a few marks, and then turn the page again. Define the shapes or objects with your lines and write words to describe the story.

CREATIVE EXERCISE
FINDING THE DOODLE

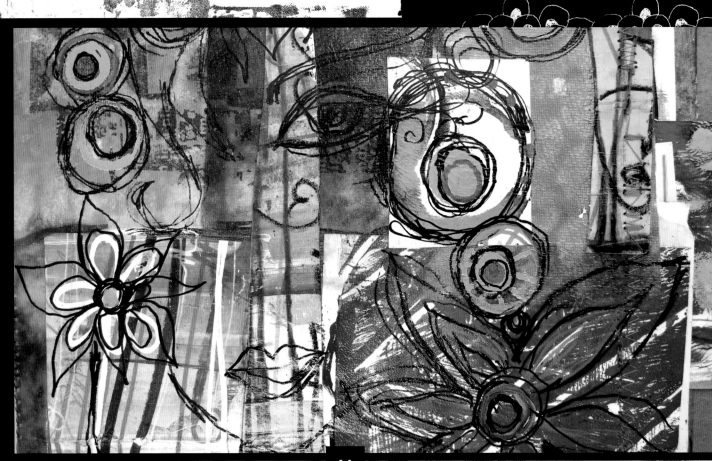

FINGERPAINTED BACKGROUNDS

Take a trip back to kindergarten and get messy with a little fingerpainting. This is a simple and fast way to get color onto paper.

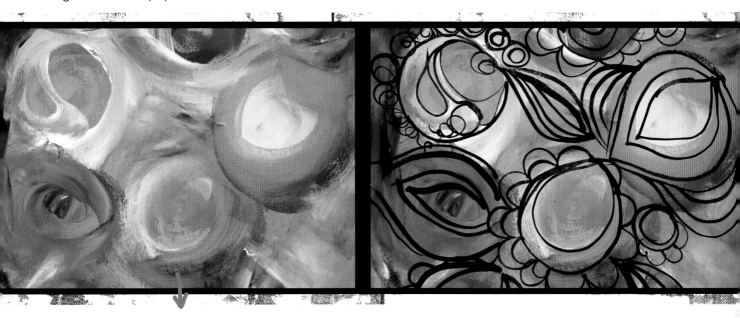

Paint two to three colors across the page with your fingers. Draw a doodle over the painting with a round brush and India ink.

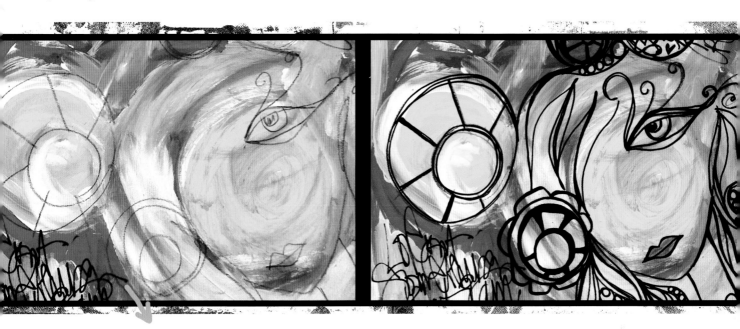

Sketch a face over the background of the painting. Define the drawing with a black oil-based paint marker. Write words or journal about your day.

TIP

If you don't initially see a design, start making marks around the main images, colors and shapes that call to you. Let your marks be flowing and free—not planned. Eventually, a design will present itself to you.

EXERCISE: INKJET PRINT BACKGROUND

A great way to leverage your artwork is to take a photo of a painted background you have created and use it as a jumpstart to reveal the doodles on the page. Take the photo with a macro lens and no flash in natural lighting so the colors remain as true to the original as possible. Print the photo on an inkjet printer. Let this background encourage your doodles. What lines can you draw from the shapes that are on the page? Start to add your marks and see where it takes you.

CREATIVE TOOLBOX

BLACK AND RED PENS (COPIC MULTILINER)

BLACK PERMANENT MARKER

COLORED PENCILS (PRISMACOLOR)

INKJET PRINTER

OIL PASTELS

PRINTED COPY OF PAINTED BACKGROUND

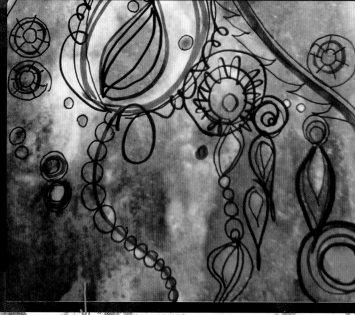

1 Using an inkjet printer, print a painted background you have photographed or scanned.

2 Doodle over the background with black and red markers, using the shapes you see in the background image. Alternate pens to add more detailed lines to your doodle. Work quickly and randomly across the page without stopping. Draw whatever comes to mind; don't think about it.

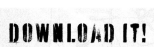

DOWNLOAD IT!

DOWNLOAD A BACKGROUND FOR THIS EXERCISE AT WWW.CREATEMIXEDMEDIA.COM/ DOODLES-BACKGROUND.

3 Fill in the doodles with colored pencils or pastels to add color to the design. Alternate colors and blend them with the background. Add more detail on top of the colors with a black permanent marker.

20

PHOTOGRAPHY INSPIRATION

For me, inspiration comes from everywhere, so I try to capture my favorite places, colors, patterns, architectural structures and flowers in photos on a daily basis. It is a way for me to record the many things that inspire me and collect images for my inspiration boards and sketchbook. I then use them as jumpstarts for my art. To cultivate your own collection of inspiration photos, start taking pictures everyday of interesting textures, signs or colors. Ask yourself, "How can I be inspired by these?" Everyone's inspiration is different, so go to a place that inspires your creative muse. It may be a museum, a zoo, an aquarium, a botanical garden or the beach. Take your camera everywhere and capture your muse.

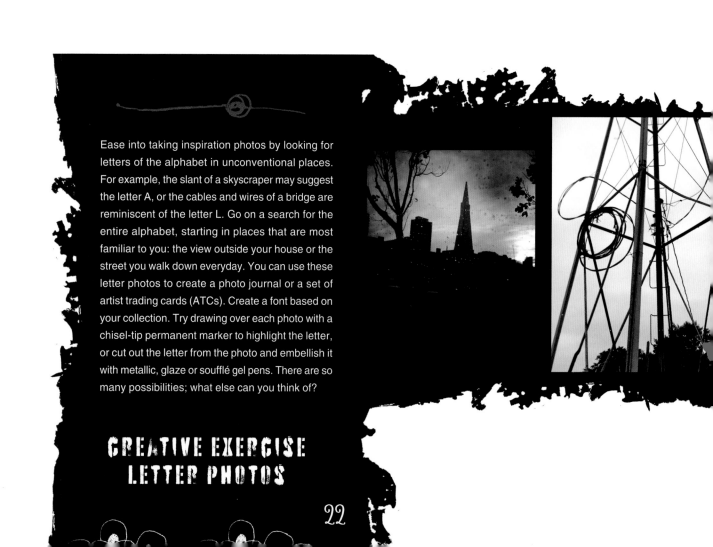

Ease into taking inspiration photos by looking for letters of the alphabet in unconventional places. For example, the slant of a skyscraper may suggest the letter A, or the cables and wires of a bridge are reminiscent of the letter L. Go on a search for the entire alphabet, starting in places that are most familiar to you: the view outside your house or the street you walk down everyday. You can use these letter photos to create a photo journal or a set of artist trading cards (ATCs). Create a font based on your collection. Try drawing over each photo with a chisel-tip permanent marker to highlight the letter, or cut out the letter from the photo and embellish it with metallic, glaze or soufflé gel pens. There are so many possibilities; what else can you think of?

CREATIVE EXERCISE
LETTER PHOTOS

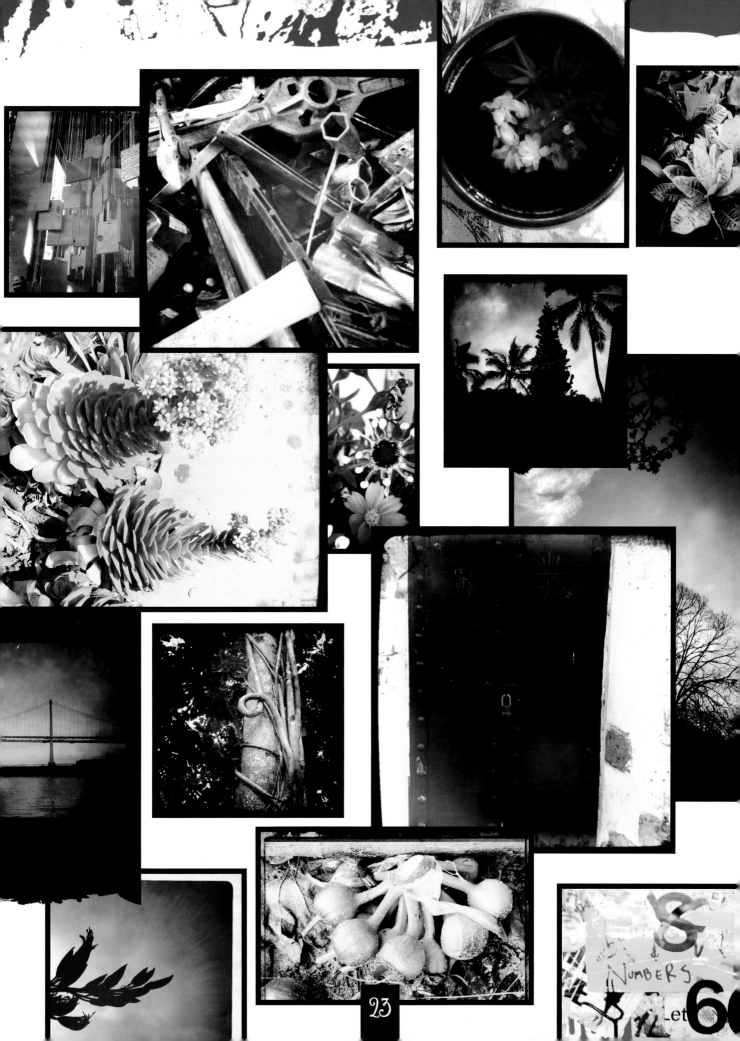

USING A PHOTO AS A DOODLE JUMPSTART

Using photos as inspiration can provide jumpstarts for shapes and lines within your doodles, as well as where to place them. When you look at a photo, seek out the unique elements in the image. Remember, you're not drawing a replica of the photo; you are looking for elements to inspire you. Study the pictures below. How can you use them to inspire your doodles? I have used different elements in these photos to inspire my lines and marks in the drawings.

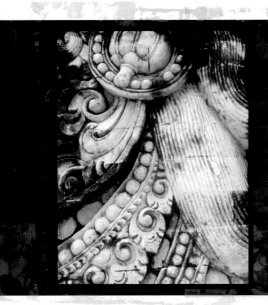

This doodle was inspired by a stone sculpture at Pura Lempuyang (Temple of 1000 Steps) in Bali. Note the circles, lines and flourishes in the photo and how they are translated in the doodle.

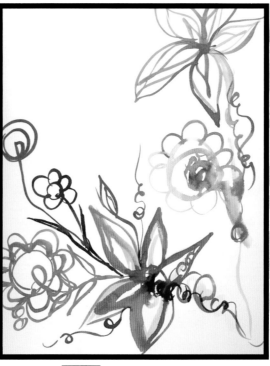

I loved the color and shape of these lilies in an arrangement, so I tried to capture these elements in this doodle painted with LuminArte Radiant Rain iridescent watercolors.

EXERCISE: PHOTOGRAPHY-INSPIRED DOODLES

Use a collection of photos with distinct patterns or lines to create a doodled piece of art. To practice, use the photo study provided below. Use elements of each photo as inspiration to create different doodles in your piece.

CREATIVE TOOLBOX

INSPIRATION PHOTOGRAPHS

WATER BRUSH

WATERCOLORS (SAKURA KOI)

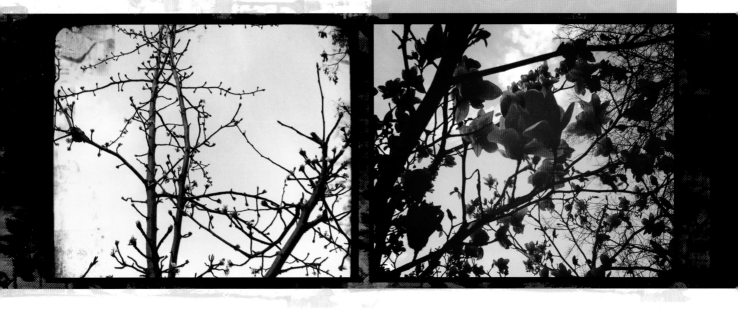

These photos show a variety of tree branches, pods and layers of foliage during early spring. They were taken with the Hipstamatic app on an iPhone, which allows you to change and play with different films, flashes and gels, resulting in amazing photos.

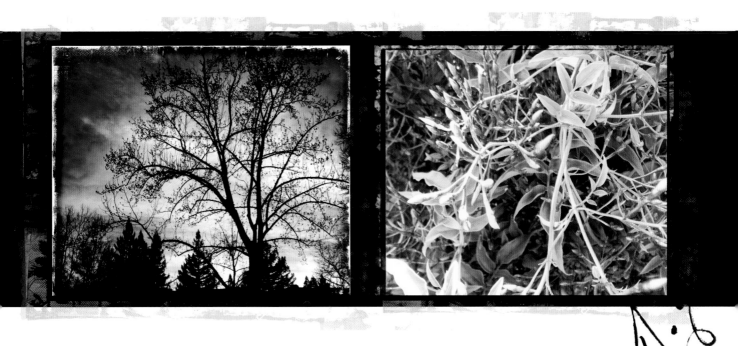

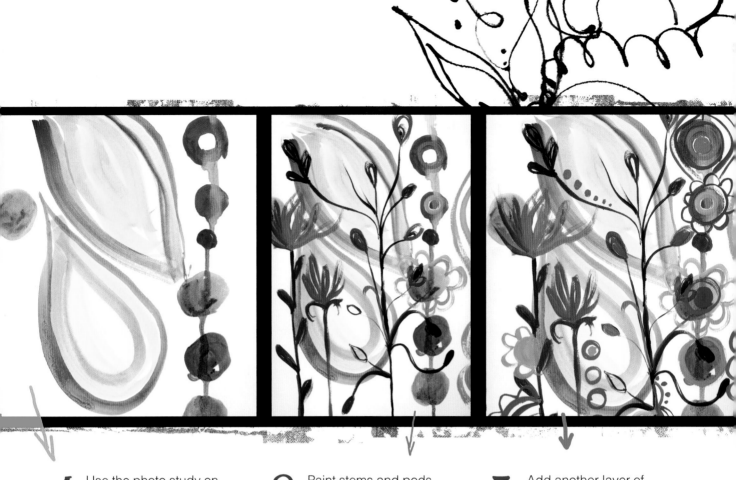

1 Use the photo study on page 25 to paint simple abstract shapes.

2 Paint stems and pods, mimicking the shapes and lines in the photos.

3 Add another layer of doodles in a different color. Study the layers of tree branches in the photos for inspiration. Add more circles and flower shapes.

4 Once the painting is dry, fill in the background with a watercolor wash.

Tip

Create a photo study with four of your personal photos. Explore and list all the items that appeal to you in the photos. How can you create doodles inspired by the pictures? Consider possible colors and lines, as well as positive and negative space.

Magazine Inspirations

Magazines in both print and online versions can provide visual inspiration for type and lettering treatments. You can easily create an alphabet exemplar using different magazine letters; photocopy the exemplar to use in a collaged background. You can also cut out shapes or photos from magazine pages to create a handmade, non-typographical alphabet.

Here are some ideas for collecting letter inspirations:

- Cut out letters from magazines and newsletters and keep them in files for later use.

- Create you own painted alphabet in Photoshop.

- Take photos of interesting signs, letters and words around your city.

- Use rub-on letters in your journals.

- Make your own letter stencils.

- Photocopy alphabets and fonts onto transparencies.

- Create a sketch alphabet.

- Carve alphabet stamps or make them out of craft foam. Remember to cut or carve letters backwards so when you stamp them they are facing the right way.

- Create a journal page of letters.

- Use the Internet! There are many great resources for typography inspiration online. Search for "free fonts"; there are numerous fonts available for personal use.

CREATIVE EXERCISE
COLLECTING LETTERS

VINTAGE FABRIC

I love to collect vintage fabric and clothing. I am continually inspired by the colors, patterns and textures in fabrics from the 1950s to 1970s. I often go to thrift, vintage and antique stores for inspiration, taking photos of the things that call out to me creatively. I use these photos to inspire my drawings and color palettes in my artwork.

Once you have many photos of vintage fabrics, you can use them to inspire painted backgrounds. Paint simple shapes with a brush and ink, acrylic or watercolor. Then draw shapes you see in the fabrics with Copic markers. This is a quick exercise to put color on paper. Notice that my paintings are not very detailed. I called out colors and shapes from the photo that I liked, but I didn't try to copy it exactly.

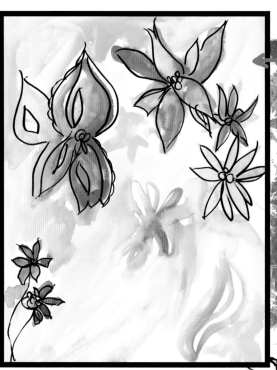

Flowers painted with watercolors and accentuated with a Copic Multiliner black pen.

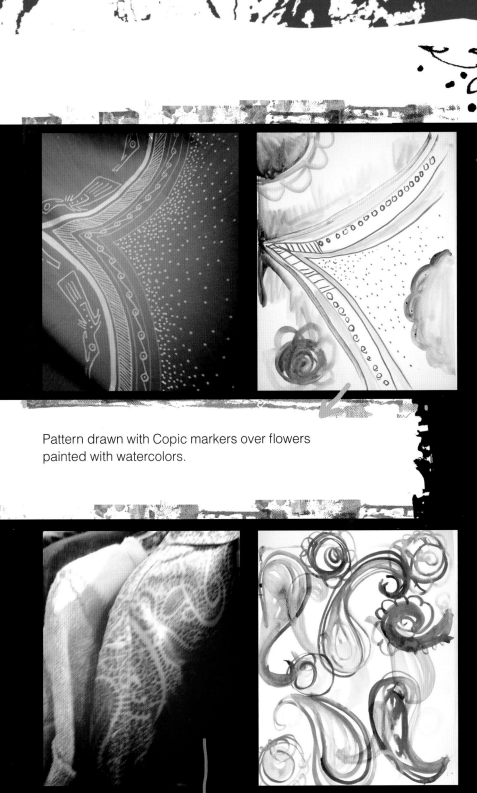

Pattern drawn with Copic markers over flowers painted with watercolors.

Explore your local thrift and vintage stores. Be sure to bring your camera and take snapshots of the fabrics and accessories that catch your eye. Here are some other places to find vintage fabrics:

- Fabric swatch books and archives: Many fabric companies have swatch books and libraries of all their fabric designs.

- Vintage fabric and fashion magazines in print and online: One of my favorites is *American Fabrics* magazine.

- Fashion blogs: Do a blog search for "vintage fabric," "print and pattern" or "vintage fashion."

- Designer-inspired books: *Designs by Erte*, *Tricia Guild Pattern* by Tricia Guild and *Pattern* by Orly Kiely.

CREATIVE JUMPSTART PLACES TO FIND VINTAGE FABRICS

Paisley pattern painted with watercolor washes using a Sakura water brush.

CREATING AN INSPIRATION BOARD

One of my favorite ways to collect inspiration is by creating an inspiration board in my art journal before starting a project or a new piece of art. I cut interesting words, letters, colors and textures from magazines and place them on the board. These clippings are great references to inspire color choices, shapes, lines, words and more. I often refer to these boards as I explore the creative process.

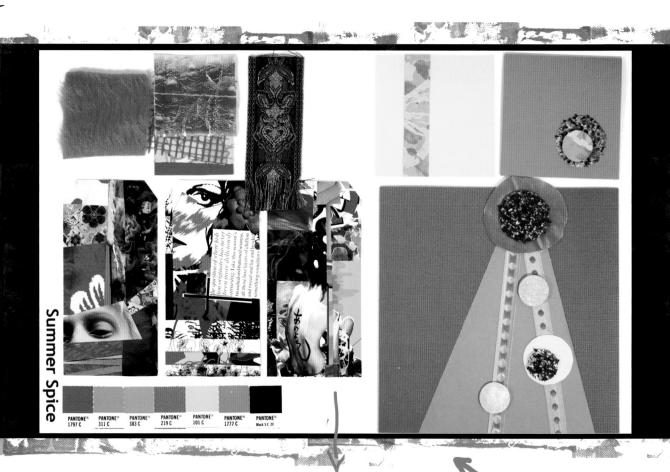

SUMMER SPICE INSPIRATION BOARD

hot . . . entice . . . fun . . .
travel . . . embroidered . . . freedom

COLOR INSPIRATIONS

I'm always asked about what inspires my art projects. Here's a peek inside my "flair" trays, where I keep random materials that inspire unique color combinations. To create your own flair tray, gather paint swatches, paper, fabric, buttons, ribbons, beads, silk flowers and other small objects that inspire color and place them in a tray. Add and remove items as you desire to create a color palette that will inspire you to doodle. My flair trays are mainly for reference, but sometimes items from the trays are incorporated in a final piece.

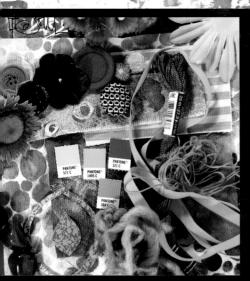 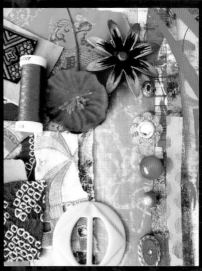 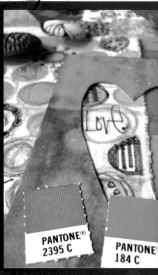

CREATIVE EXERCISE
COLLECT INSPIRATION

- Collect photos from your own collection, online or from magazines. A few of my favorites are *Garden Design* magazine for floral pictures, and *Juxtapoz* and *Beautiful/Decay* for graffiti inspiration.
- Do an image search online for "graffiti art," "flowers" or your project theme.
- Brainstorm a list of words and phrases.
- Practice drawing shapes in your sketchbook or journal.
- Go for an inspiration walk and take photos.
- Go to your favorite stores and take notes on color trends, patterns and fabrics.
- Collect Pantone paint chips and paint swatches.

Doodling is a form of visual storytelling, and the story begins with the background. The graffiti-inspired backgrounds I create are a mash-up of scratches, splashes of vibrant colors and marks made with found tools and collage. Creating these marks and layers of scribbles is my way of telling stories. There are days when my marks are slow and controlled and others when they are wildly strewn, sprayed and scribbled over the surface. In this chapter we will focus on creating colorful layers and backgrounds to tell our stories and inspire marks.

surfaces I can cover with collage. Don't limit yourself to a blank sheet of paper!

As I create, it's important that every aspect of my art, down to the collage elements, be created by me. I make photocopies of my original artwork and use them as collage sheets to ensure that my pieces are completely "mine." Collage sheets can be created from painted and collaged backgrounds, typefaces, stamped patterns and any marked or lettered background.

With my background in graphic design, the computer has always been an integral part of my

ORGANIC BACKGROUNDS

Nothing is off limits when it comes to choosing surfaces. I paint and doodle on traditional surfaces like fabric, wood and paper, as well as found and recycled papers like cardboard and heavy mailing envelopes. My collection includes interesting postcards, receipts, tags, stickers and free newspapers. I'm always on the hunt for paper treasures and scour thrift stores for unique

creative process. Altering, painting and doodling on the computer enhances my handmade creations. The iPhone has also become a standard in my creative toolbox. I use the photographs I take on it to create digitally merged surfaces for collage and painting.

Creating, gathering and hunting for unique surfaces is part of the creative process. Explore all the possibilities.

SURFACES AND BACKGROUNDS

Think outside the box when it comes to surfaces and backgrounds to use in your artwork. You can doodle and draw on just about any recycled surface—mailing envelopes, paper grocery bags, muslin—and over most painted or collaged backgrounds. Here are some examples of the possibilities.

Circle monoprints

Stamps, sequin waste and hand-cut stencil prints with acrylic paint on tissue paper

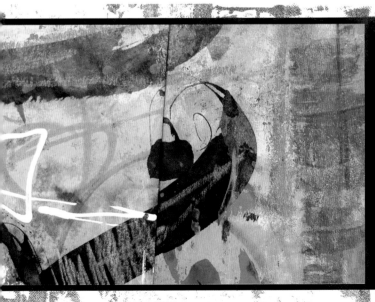

Graffiti layers on a brown paper bag

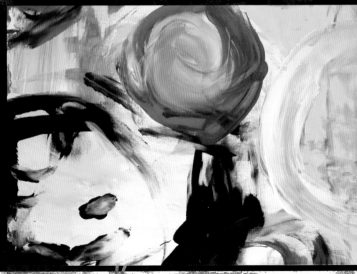

Fingerpainted background

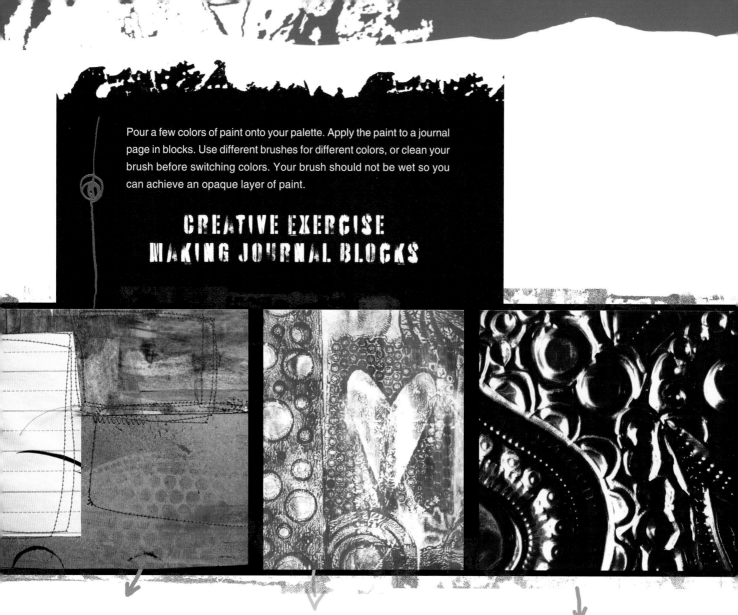

Pour a few colors of paint onto your palette. Apply the paint to a journal page in blocks. Use different brushes for different colors, or clean your brush before switching colors. Your brush should not be wet so you can achieve an opaque layer of paint.

CREATIVE EXERCISE
MAKING JOURNAL BLOCKS

Journal blocks and painted paper stitched together

Random stamps and doodles made with sequin waste and hand-cut stencils

Craft metal with doodles

Tip

Challenge yourself! Create seven different backgrounds in ten minutes.

WATCH IT!

CRAFT METAL IS A UNIQUE SURFACE TO EMBELLISH WITH DOODLES. CREATE AN ENTIRE BACKGROUND, THEN STAIN IT WITH PAINT OR INK. THESE METAL SHEETS ALSO MAKE GREAT COLLAGE PIECES AND EMBELLISHMENTS THAT YOU CAN STITCH TO ART JOURNAL COVERS. WATCH A DEMONSTRATION ON DOODLING ON CRAFT METAL AT WWW.CREATEMIXEDMEDIA.COM/DOODLES-METAL.

REPETITIVE PATTERNS

A simple black line can be exquisitely embellished to create vibrant layers of repetitive patterns. After drawing the basic repetitive doodle, add more detail with thicker black lines and contrasting shades of markers. It's exciting to work randomly throughout the painting. See the adjacent page for just a few possibilities.

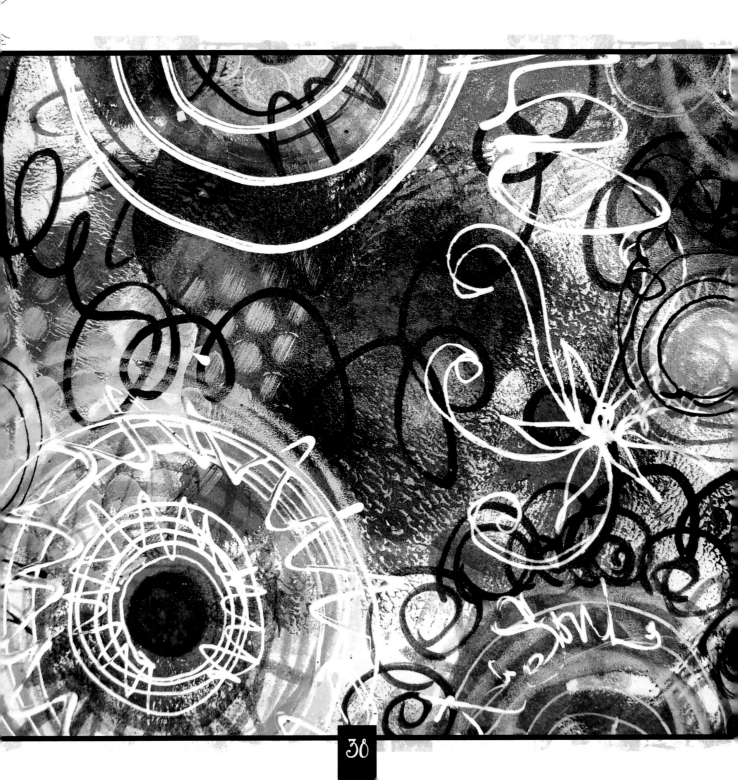

Sumi ink painted on watercolor paper with a round brush and skewer

Gesso painted over an acrylic paint background with black sumi ink flowers painted over top

Acrylic paint stamped and painted in circular shapes and flower patterns drawn with India ink on drill cloth

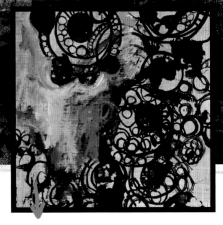

Circles drawn with India ink using a small brush on handmade papyrus paper, with a portion covered in a mixture of paint and gesso

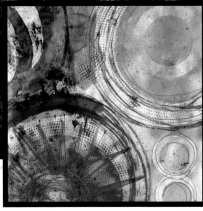

Paint sprayed through circular needlepoint canvas and chipboard stencils with scribbles of oil pastels and colored pencils

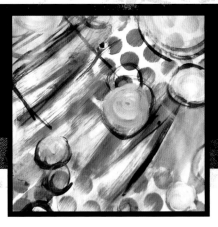

Dots created by paint through sequin waste, with larger circles, lines and boxes painted in contrasting colors

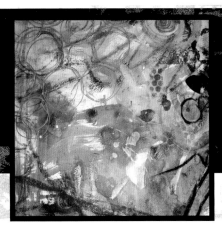

Paint wash on a paper bag with a transparency monoprint of circles over the top

Black lines drawn with an oil-based paint marker

Scribbles and doodles from various markers, a correction fluid pen, black glaze, and chisel-tip and fine-tip permanent markers over a painted monoprint

EXERCISE: CIRCLE DOODLES

Repeating a simple circular pattern can yield interesting results. Create collage papers or backgrounds in paintings using repetitive patterns.

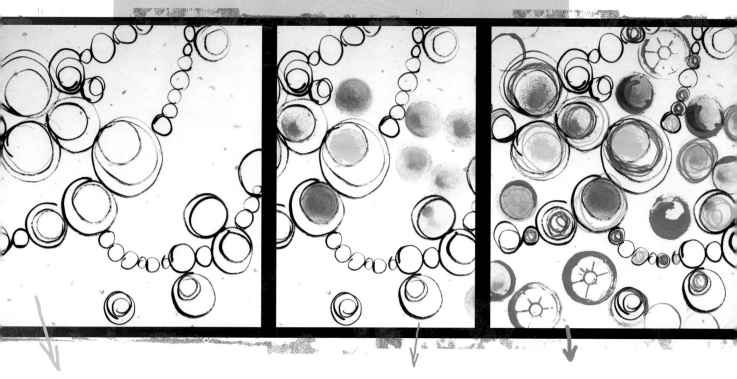

1 Paint circles on handmade paper with India ink and a size 1 liner paintbrush.

2 Apply two to three shades of green acrylic paint to the surface with a dauber foam brush.

3 Add circle doodles with colored pencils.

4 Stamp red paint onto the surface with circular tools, such as the bottom of a spool of thread or paint bottle. Draw circles with dimensional fabric paint.

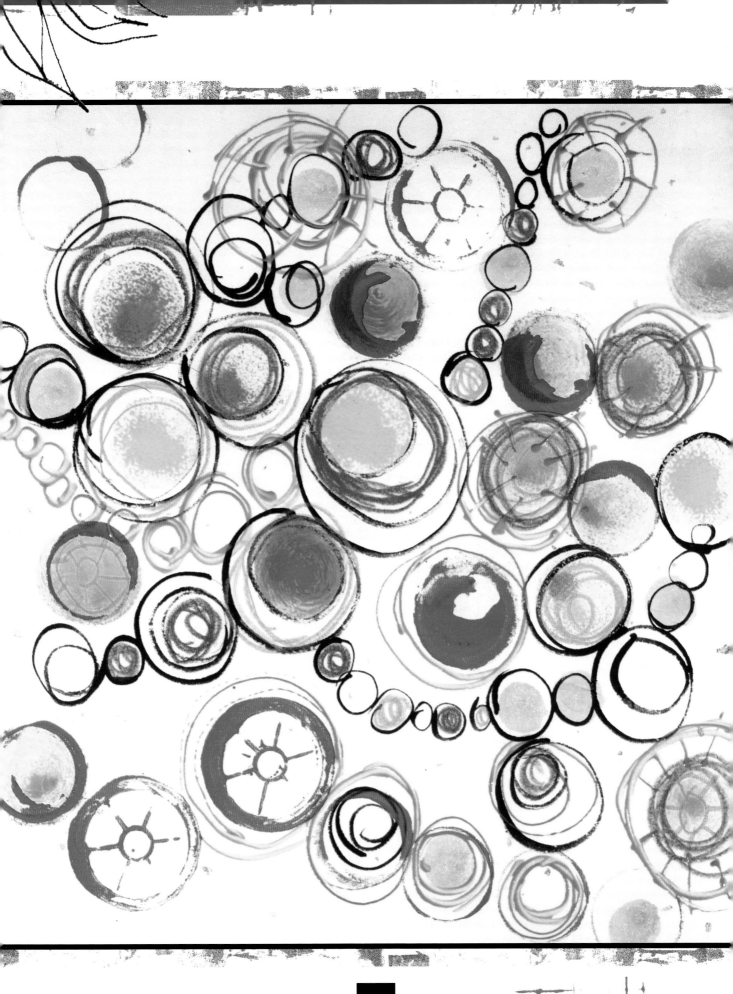

RESIST SCRIBBLES

The resist scribbles technique is a little twist on a craft paint favorite. It involves print-making with dimensional paint! Scribble dimensional fabric paint onto a transparency, then flip it over and press it onto paper or fabric. Once it dries, the paint creates a raised resist texture.

EXERCISE: RESIST SCRIBBLE TRANSPARENCY MONOPRINT

Create resist scribbles by doodling with dimensional paint onto a transparency and making prints. This is a great way to add textured paint layers to your canvas!

CREATIVE TOOLBOX

1" (2.5CM) FOAM BRUSH

ACRYLIC PAINT

DIMENSIONAL FABRIC PAINT (TULIP SLICK)

PAPER OR FABRIC SURFACE

PLAIN TRANSPARENCY FOR PHOTOCOPY MACHINE

1 Scribble words onto a transparency with dimensional fabric paint.

2 Flip the transparency onto a piece of paper or fabric and rub the entire transparency lightly on the back to transfer the print onto the surface. Pick up the transparency and place it on another part of the surface and take another print with the leftover paint. Let the page dry completely.

Tip

Squeeze the bottle lightly and draw quickly over the surface. For the best results, make sure the tip of the bottle touches the top of the transparency.

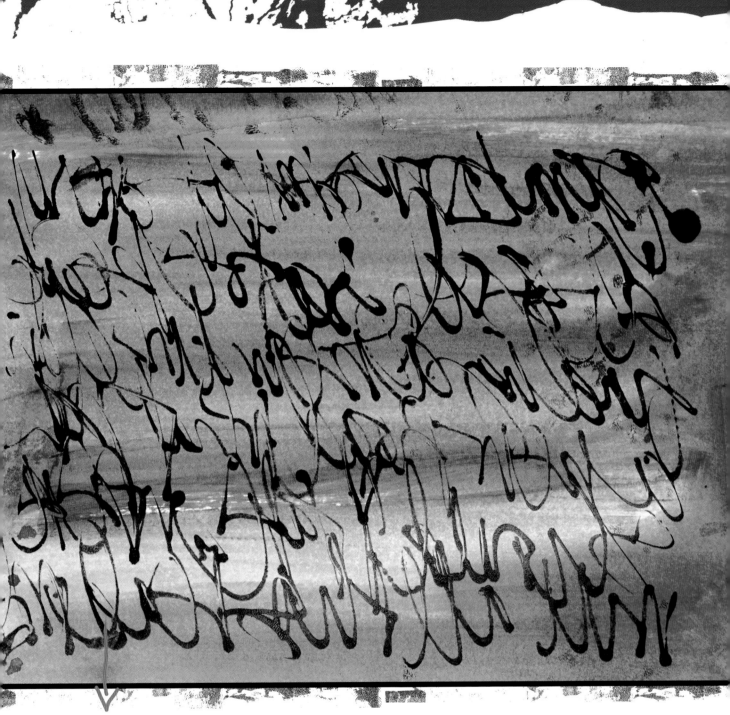

3 Create a wash by dipping a foam brush into water and two colors of acrylic paint. Brush the paint wash over the entire surface of the resist scribble. The printed scribbles act as a resist.

TIP

Experiment with different colors of dimensional paint. One of my favorites is white, because some paint washes will dye the white color.

REPURPOSED PHOTOCOPIES

Revamping my art is a constant occurrence in my studio. One way to do this is to use repurposed photocopies. I have been using photocopies in my artwork from the beginning. I create my own collage sheets from my original artwork. This way, each piece has a part of a previous piece of art as a reminder of where my art has come from.

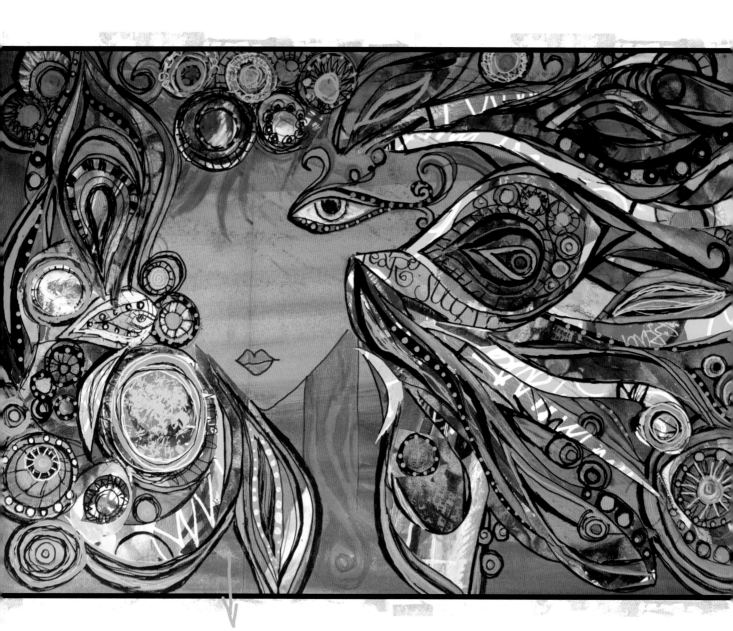

I cut shapes from laser copies and adhered them over a painted watercolor paper. I let these shapes inspire my doodles. The lines in the hair are made with a black oil-based paint marker.

Make black-and-white photocopies of your original doodles and then cut them apart and collage them into new art! This is the first layer of a painting. I cut abstract flower shapes from my black-and-white photocopies.

Cut circles and strips from color photocopies and adhere them to an index card with Collage Pauge.

Take some time to leverage your art! One thing I always do when I am working on a painting or piece of art is make copies, take photos or scan the originals. I take pictures of art in progress, photocopy the covers of my journals and art quilts and then enlarge the art on the copier. These pieces are used in collage or art journal pages, or are stitched into quilts. Sometimes they are altered with paint and gesso. The photocopies provide interesting colors, shapes and backgrounds for my new art.

Here are a few things you can do:

- Enlarge writing on journal pages until the letters are blown out.
- Print photographs and enlarge them on a photocopier in color and black and white.
- Take photos of artwork in progress and finished pieces.
- Take photos of artwork at different angles. Scan artwork.
- Alter artwork in Photoshop, at www.picnik.com or with an iPhone app like ArtStudio or Pictureshow.
- Photocopy on 11" × 17" (28cm × 43cm) paper and use the photocopies as journal pages.
- Take photos of your printing plates.

CREATIVE EXERCISE
LEVERAGING YOUR ART

EXERCISE: PHOTOCOPY FLOWER COLLAGE

Transform your painted papers with collage. Another fun exercise for finding the doodle in a painted background is adding collage. Take a simple background and transform it into a piece of art with bits of photocopies and hand-painted papers.

CREATIVE TOOLBOX

140 LB. (300GSM) VISUAL JOURNAL WATERCOLOR PAPER (STRATHMORE)

ACRYLIC PAINT

BLACK OIL-BASED PAINT MARKER (SHARPIE)

COLLAGE PAUGE

COLOR AND BLACK-AND-WHITE LASER PHOTOCOPIES

COLORED MARKERS

HANDMADE STAMPS

PAINTED BACKGROUND

SCISSORS

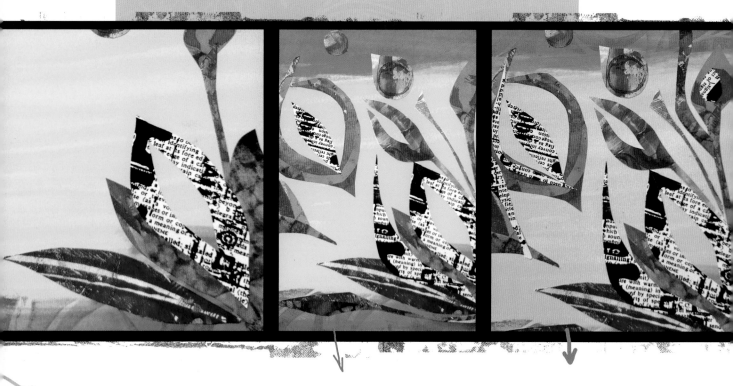

1 Cut flower and leaf shapes from color and black-and-white photocopies of your art. Collage these shapes onto a painted background.

2 Continue to add more shapes, alternating between color and black and white.

3 Layer collage pieces to accent colored pieces. Cut shapes without drawing them—freestyle!

4 Draw doodles of flower shapes around the collage pieces with colored markers and a black oil-based paint marker.

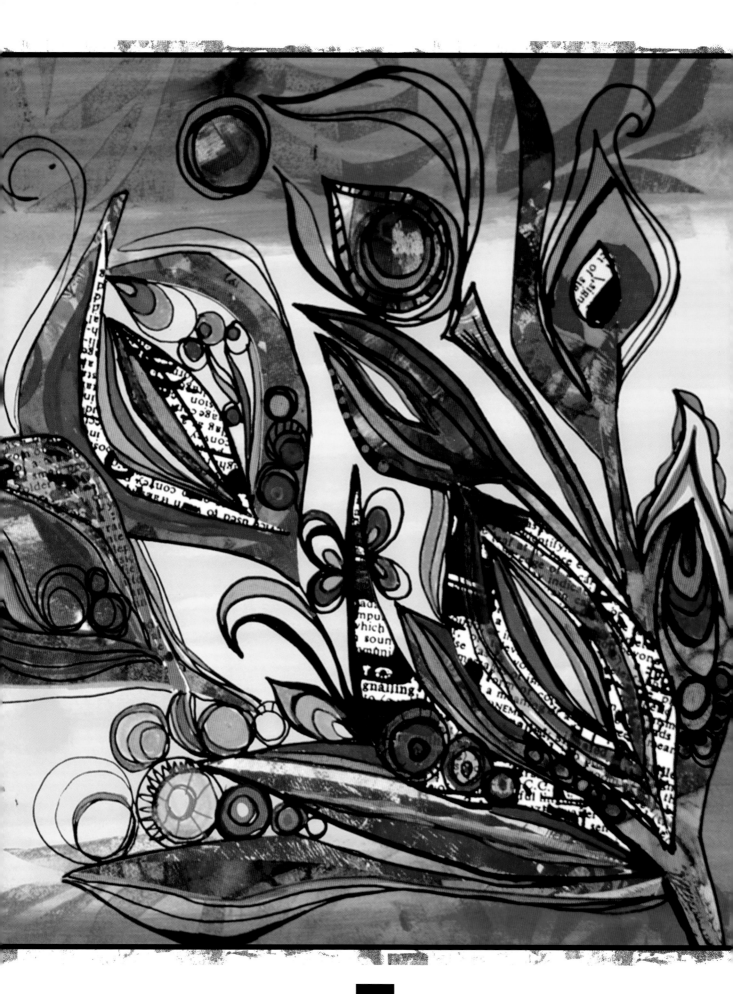

GRAFFITI TISSUE PAPER

Tissue paper is a great material for collage because it dries transparent. When there are designs in black ink or paint on the tissue, you are left with a nice contrast over the background once it dries. Its thin consistency makes it great to layer in collage. I create my own collage tissue papers by layering stamps, scribbles and doodles with various pens and markers.

EXERCISE: GRAFFITI TISSUE PAPER

Add creative transparent layers to your artwork! Make your own collage sheets by layering letters, words or stencils onto tissue paper.

CREATIVE TOOLBOX

BLACK CHISEL-TIP PERMANENT MARKER	MARKERS (COPIC AND SAKURA PERMAPAQUE)
FUCHSIA FINE-TIP PERMANENT MARKER	RED HIGHLIGHTER
	WHITE TISSUE PAPER

1 Write words on white tissue paper with a black chisel-tip permanent marker. Overlap them as you work.

2 Continue adding layers of writing with a red highlighter and a turquoise marker.

3 Accent the design with a fuchsia fine-tip permanent marker. Draw doodles and write more words with different colored markers to fill the white space.

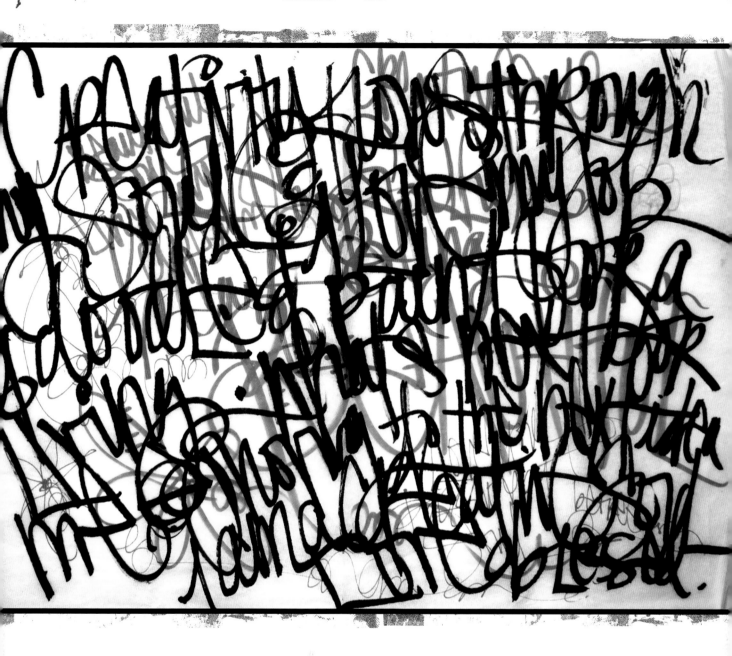

- Try out stamping, stenciling (see page 54) and printing with resist scribbles (see page 42) on tissue paper, too.

- If using paint sprays, be careful not to saturate the tissue; it will tear.

- Use permanent markers to prevent bleeding when tissue is collaged. Let paint and markers dry completely before collaging it.

- Place scrap paper under your surface to prevent staining your table.

- Experiment with different black-and-white designs, such as writing with a white correction fluid pen on black paper. These two shades create a nice contrast from most backgrounds.

Variation: The graffiti tissue paper technique with stamped, printed and stenciled images.

TYPEFACE COLLAGE SHEETS

Many of my paintings and visual journal pages start with a layer of collage. My stories are told with minimal words, but I still like to express feelings and emotions through the beauty of letterforms. I make my own typeface collage sheets by layering different fonts either digitally or by hand-stamping. Create your own personal stories by creating typeface collage sheets.

Here are some ideas for creating typeface collage sheets:

- Enlarge your handwritten journal pages and print them out on a photocopier.
- Write your story with a large permanent marker, overlapping the words.
- Paint words or phrases with a brush and sumi ink.
- Place letter stickers over a painted background.
- Take photos of different letters on signs and billboards and create a collage sheet.
- Take photos of your art journal pages and digitally merge them.
- Spray through letter stencils and chipboard letters with paint.

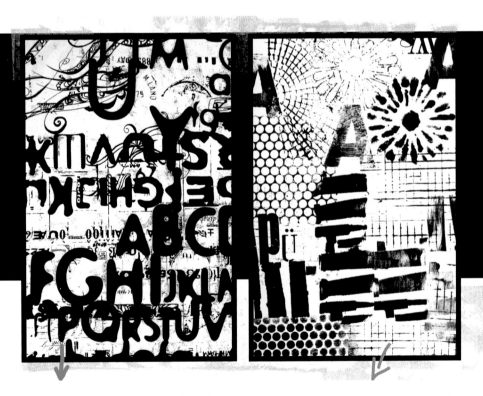

Photocopy samples of your favorite fonts onto transparencies and overlay them onto a doodled design. Make black-and-white copies of the layers.

Stamp letters and patterns onto vellum bristol and paint through stencils to create letter backgrounds. Use this sheet in an art journal or collage.

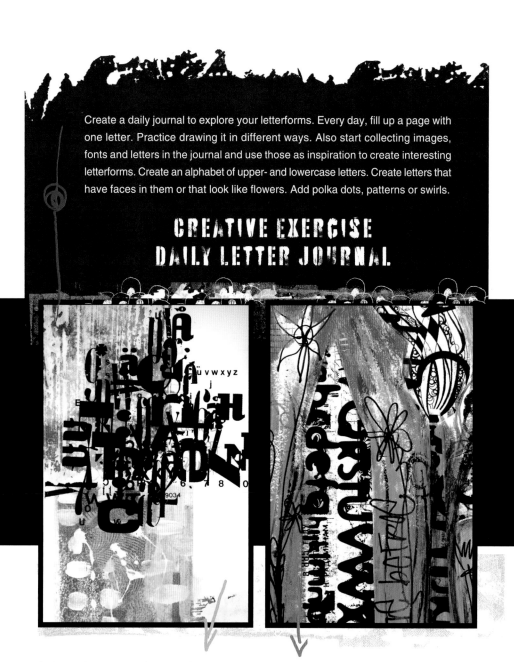

Create a daily journal to explore your letterforms. Every day, fill up a page with one letter. Practice drawing it in different ways. Also start collecting images, fonts and letters in the journal and use those as inspiration to create interesting letterforms. Create an alphabet of upper- and lowercase letters. Create letters that have faces in them or that look like flowers. Add polka dots, patterns or swirls.

CREATIVE EXERCISE
DAILY LETTER JOURNAL

Rub-on letters can be used to create a one-of-a-kind collage sheet. Layer rub-on letters in several different fonts and sizes over a painted background. Turn the page as you work so the letters are facing in different directions.

Create a letter design using your favorite fonts in a word processing program or Photoshop. Randomly write words or just play with the letters by changing the size or overlapping them. Print the design and make photocopies. Cut the photocopies into pieces and collage them onto a canvas. Paint over the photocopies and let some of the lettering peek through the paint.

TRANSPARENCY LAYERS

Transparencies can be used in a number of ways to add dimension and layers to your art. They make great printing plates for painting, you can adhere rub-on letters to them, stitch them into journals or use them as pages or in handmade jewelry. I also use them as a base for journaling and writing.

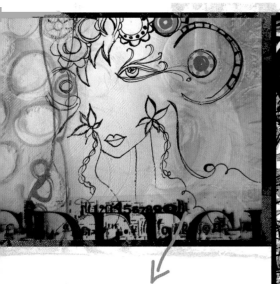

Create layered images by layering paint and transparencies. A "girlie glam" doodle drawn on a paper collage canvas (see page 58) layered with a painted resist transparency and a typeface collage sheet.

This image is created by layering two black-and-white transparencies printed with doodles and collage artwork.

Use leftover transparencies from resist scribbles (see page 42) to create overlays. This piece is composed of three layers: a painted vintage ledger and two painted transparencies. Arrange them in different ways to create designs.

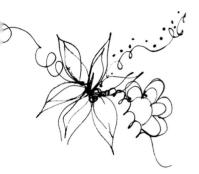

Use permanent markers and gel pens to write on the transparency surface, then stitch it to two painted transparency layers and layer doily rub-ons on top.

STENCILS

Some of my favorite tools are handmade and found stencils. From needlepoint canvas to silk flowers to hand-cut postcards, many of my marks start with a layer of paint sprayed through stencils. I look for items with interesting patterns and textures. There are so many interesting tools to use as stencils. Teach yourself to "look with new eyes" when you are shopping. Stencils can be found at many places, not just the art store. Experiment with designing shapes to add visual imagery to your paintings with interesting textures.

A few of my favorite stencil tools: anything containing the alphabet, including chip-board letters and letter alphabet stencils; leaves and flowers cut with a craft knife; plastic overlays; a gutter screen from the hardware store; a felted placemat from a dollar store; and lasercut stencils by Stencil Girl Products.

Make stencil prints by laying stencils over the surface. Spray Tulip fabric sprays or watercolor in a spray bottle over the stencils. You can also flip painted stencils over onto the surface and roll over them with a soft rubber brayer to transfer the excess paint and make a print of the stencils. Try using store-bought stencils, needlepoint canvas, silk flower petals, sequin waste, removable stickers, masking tape, foam hair rollers, rubber bands, sink mats or string to make prints.

CREATIVE JUMPSTARTS STENCIL PRINTS

Cut stencils from cardstock and place them onto the surface. Spray Tulip fabric sprays over the stencil to create an outline. Then turn the painted stencil onto the fabric and roll over it with a soft rubber brayer to take a print. The excess paint on the stencil will transfer to the surface.

Make various stencil prints (see the Creative Jumpstart on page 54) by spraying through sequin waste and lasercut plastic masks by Maya Road. Doodle with Aleene's Fabric Fusion adhesive and sprinkle ultrafine glitter over the glue. Let it dry. Write words over the wet paint with a white correction fluid pen.

Spray through letter stencils, sequin waste and needlepoint canvas. Once the paint is dry, accent the background with black Tulip SLICK dimensional fabric paint.

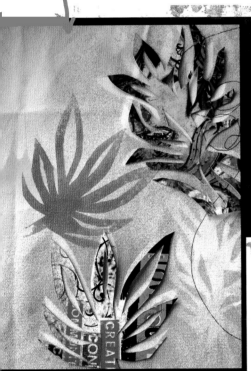

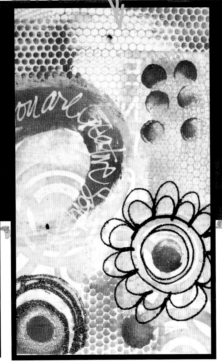

TIPS

- Look around your home, kitchen and garage. What items do you have that can be turned into stencils? My favorite places to find stencils are thrift, dollar and hardware stores.

- Look for lasercut cardstock in scrapbooking stores.

- Use stickers and tape as stencils.

- To create custom designed stencils, I cut intricate designs out of cardstock, manila folders or discarded postcards. You can find free postcards at many coffee shops.

- For interesting letter stencils, use a variety of chipboard letters in different fonts.

EXERCISE: FABRIC STENCILED BACKGROUNDS

This is a simple and fun way to add patterns to your painted backgrounds with stencils found at the dollar store. Look with fresh eyes for unique tools to create interesting patterns in your art. This technique can be done on a variety of surfaces. Experiment with different fabrics and papers.

CREATIVE TOOLBOX

ACRYLIC PAINT

FABRIC PAINT (TULIP SOFT)

FABRIC SPRAYS (TULIP)

FOAM BRUSH

STENCILS SUCH AS SILK FLOWERS, CROCHETED DOILIES, RUBBER BANDS AND CHIPBOARD LETTERS

UNBLEACHED MUSLIN

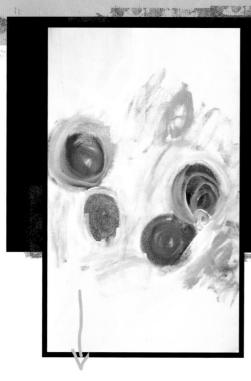

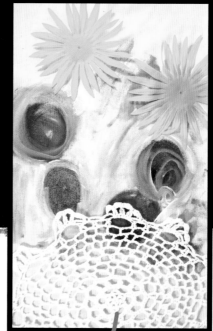

1 Paint a piece of unbleached muslin with various acrylic and fabric paints.

2 Pull apart a silk gerbera daisy to use as a stencil. Place a crocheted doily and silk petals over the painted background.

3 Spray fabric sprays over the stencils, then remove them to reveal the pattern.

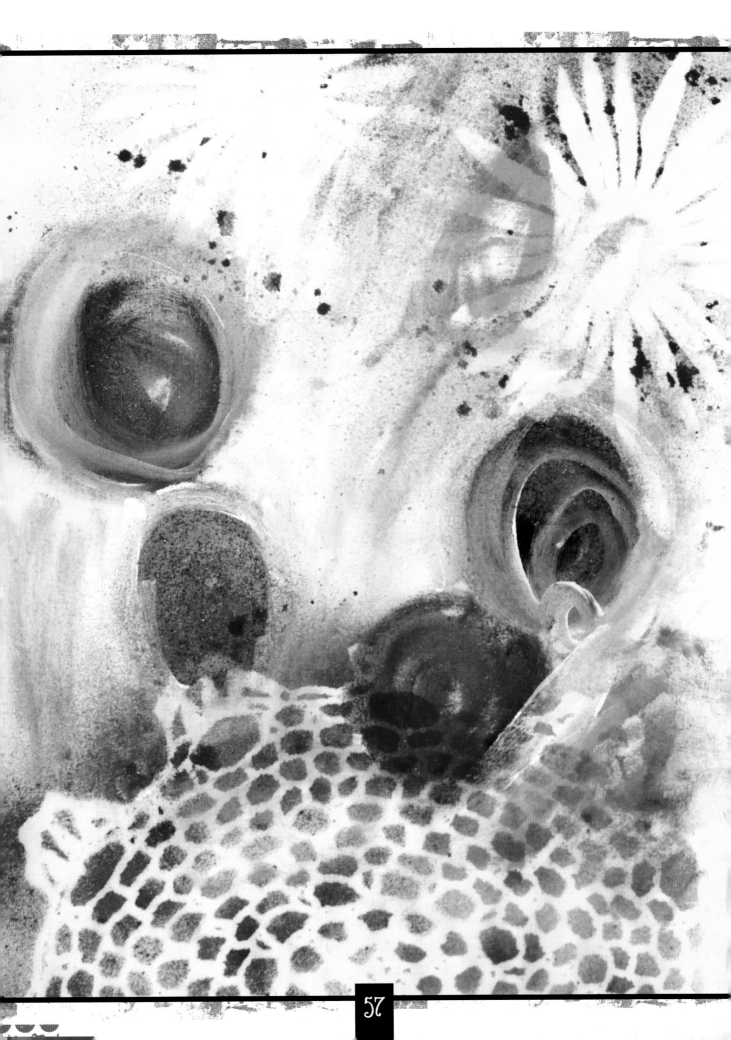

COLLAGE CANVASES

The marriage of paper and adhesive is often the base layer of my paintings. I collage paper shapes onto the surface, sometimes in a patchwork pattern and other times organically on the page, to prepare my artwork for layers of paint and doodling. Finding the doodle in collage elements can be a challenge, but it is often a great exercise to help jumpstart the mark-making process.

Explore creating collage canvases with papers, photos and photocopies! Here are some ideas:

● Consider using unusual fabrics and papers as a base for collage. Some examples include Tyvek material, manila folders, drill cloth and osnaburg fabric.

● Create graffiti tissue paper (see page 48) and collage it onto canvas. Thinner or more transparent papers, like tissue and napkins, work great to build up canvas layers.

● Place a stencil on your canvas and spread molding paste over it to build up texture. Embed stickers, tape or silk flowers in the paste. Since molding paste dries to an off-white shade, I also adhere paper pieces with Collage Pauge Matte if I want the paper surface to show through the adhesive. The more layers you collage, the longer it takes for the entire piece to dry. You may need to let it sit overnight.

● To obtain a smoother finish, you can iron the canvas while it is still damp. Place the canvas between two sheets of parchment paper and iron it until it is dry. Let the canvas sit until it is cool, then peel off the parchment paper.

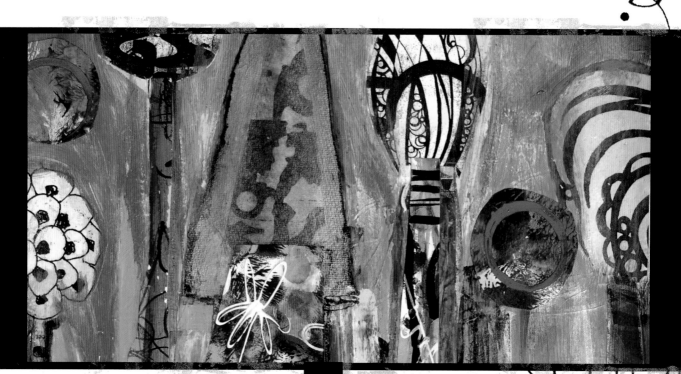

BASIC COLLAGE CANVAS TECHNIQUE

Make your own canvas backgrounds from natural fiber papers. These canvases are flexible, with a fabric and paper feel. They can be painted, collaged and doodled over. Use them alone or turn them into art journal covers.

Lay a piece of freezer paper shiny side up over your surface. Apply a layer of molding paste onto freezer paper, press handmade paper onto molding paste, and work on small sections at a time, overlapping shapes. Tear or cut more handmade paper and apply more molding paste to build a thicker canvas or use Collage Pauge for the final layers of paper.

Collage layers of mulberry, lace and Asian handmade papers on top of a cardboard mailing envelope. Doodle a girlie glam face (see page 92) on the canvas with India ink and a round brush.

Create a canvas with layers of handmade papers, then paint over it with acrylic paints. Cut painted papers and tissues into the shape of a house and a heart. Write the word *love* with a white correction fluid pen on tissue paper and adhere it to the canvas with Collage Pauge.

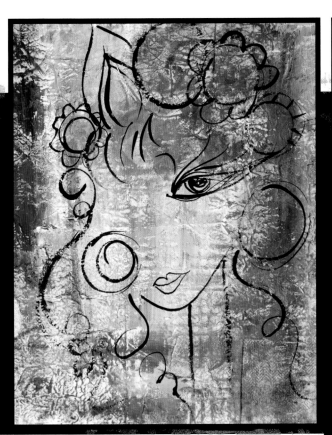

EXERCISE: PAPER LAYERS CANVAS

Natural fiber papers and neutral-colored lace create a great base for a collage canvas. Cut or tear these materials into smaller pieces and collage them to your selected background. Fabric, cardboard or a manila folder are all great options.

CREATIVE TOOLBOX

1" (2.5CM) FOAM BRUSH

BASE SUCH AS FABRIC, CARD-BOARD OR A MANILA FOLDER

COLLAGE ITEMS SUCH AS HAND-MADE PAPER, LACE, THIN PAPERS, NAPKINS, DYED PAPER TOWELS AND TULLE

COLLAGE PAUGE

EMBELLISHMENTS SUCH AS STENCILS, TAPE AND SILK FLOWERS

FREEZER PAPER

MOLDING PASTE (GOLDEN)

PALETTE KNIFE

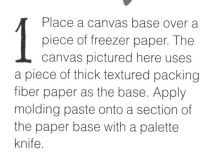

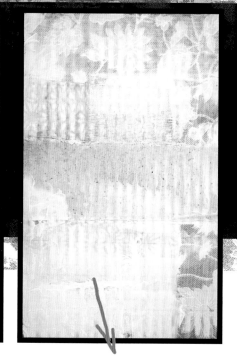

1 Place a canvas base over a piece of freezer paper. The canvas pictured here uses a piece of thick textured packing fiber paper as the base. Apply molding paste onto a section of the paper base with a palette knife.

2 Cut or tear handmade papers and place pieces in the molding paste. Using a foam brush, apply Collage Pauge as needed to each paper layer.

3 Continue to add molding paste and place more paper until the base is completely covered.

GRAFFITI COLLAGE PANELS

Create visual journal boards from recycled materials like cardboard. Cardboard panels make great surfaces for deconstructed layers of torn paper, drips of paint and personal graffiti. They can be scratched with scissors or an awl to tear away portions of the top layer of paper so you are left with the corrugated texture. The panels are perfect for stand-alone collage paintings, but they can also be stitched to use as covers for visual journals.

The first step to creating the mixed-media layers on the panels is to add black-and-white doodles and words or collage photocopies onto the surface. I like to cut my panels into 7" × 11" (18cm × 28cm) pieces, so they are long and narrow.

Paper is torn away from the cardboard panel. I used a black chisel-tip permanent marker to write the words.

This panel has black-and-white photocopies of my photos from Thailand and typography collage sheets glued to the surface. The photocopies will be painted over with a wash of acrylic paint. I usually cover only a portion of the panels with photocopies.

For this panel canvas, I wanted a raw edge, so I tore the photocopies. The top layer of paper is peeled back from the panel to reveal the corrugated texture. Over the black-and-white backgrounds, the top layers are stained with acrylic paint washes, and more of my writing and doodles are incorporated.

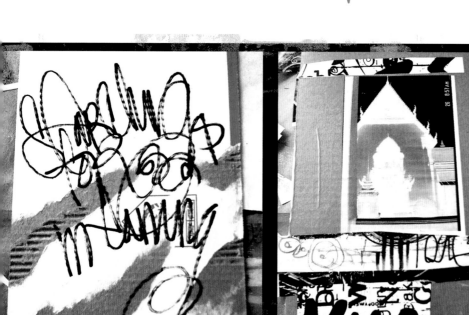

Here the top layer is created with a messy application of paint with a foam brush. Once the first layer of collage and paint were dry, I loaded a foam brush with water and added a little paint. I then tilted the board down to form the drips of paint that run down the panel.

The bottom layer of photocopies shows through on this panel. I painted with acrylics around the main image of the temple and added lines with Prismacolor colored pencils. The photocopy is stained with PanPastel soft pastels.

This panel has a layer of cardboard shapes glued to the surface before it's painted. The simplicity of the background color with the bright contrast of the red painted cardboard shows how you can layer pieces of cut cardboard on top. Glue the cardboard with tacky glue, then let it dry.

The first layer of this panel has found paper and photocopies collaged to it. I painted over the flower with acrylics and used a black oil-based paint marker to outline the shapes and add contrast with fluorescent pink and white paint pens.

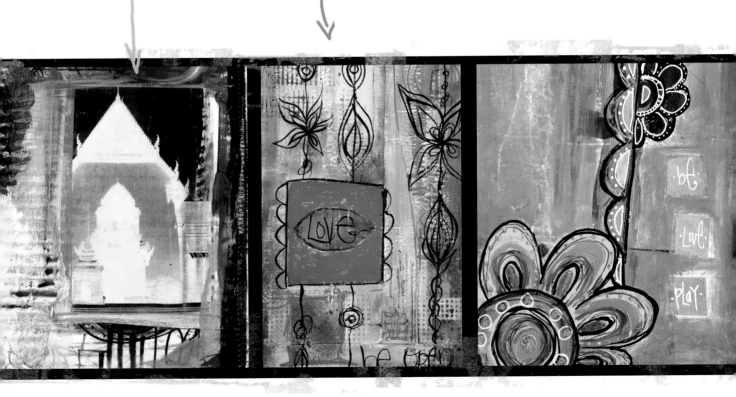

EXERCISE: GRAFFITI BOUQUET

Inspired by the juxtaposition of colorful urban graffiti walls and blossoming gardens, my graffiti bouquet paintings are visual journal collages with extreme color and texture in rich, vibrant layers. They combine "fusion dyed" collage, monoprints, freestyle lettering and doodling. The paintings are layered with black-and-white images, expressive marks and personal graffiti.

 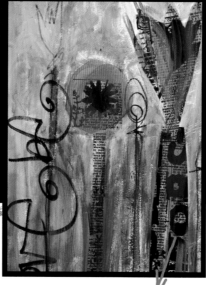 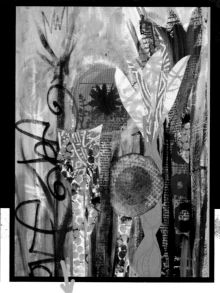

1 Spread gesso onto the page with a foam brush. Swirl the brush in a circular motion to add texture. Scratch words, floral shapes and other marks into the gesso with a skewer. Let it dry. Doodle and write words with a black chisel-tip permanent marker.

Cut flower shapes from photo-copies of your artwork and collage them onto the surface using Collage Pauge. Seal the collage with another layer of Collage Pauge.

2 Paint over flower shapes and stems with acrylic paints. Fill in the background with acrylic paint, mixing different shades on the page.

3 Paint the stems and leaves in darker acrylic paints using a flat brush. Cut flower shapes and stems from handpainted paper and collage them on top of the painting.

CREATIVE TOOLBOX

1" (2.5CM) FOAM BRUSH

140 LB. MIXED-MEDIA PAPER 500 SERIES (STRATHMORE)

ACRYLIC PAINT (MATISSE DERIVAN)

BLACK-AND-WHITE PHOTOCOPIES OF ORIGINAL ARTWORK

BLACK CHISEL-TIP PERMANENT MARKER

COLLAGE PAUGE

DIMENSIONAL FABRIC PAINT (TULIP SLICK)

GESSO

MARKERS (COPIC)

ROUND AND FLAT PAINTBRUSHES

SOLIDIFIED PAINT MARKER (SAKURA)

SCISSORS

SKEWER OR OTHER MARK-MAKING TOOL

WHITE CORRECTION FLUID PEN

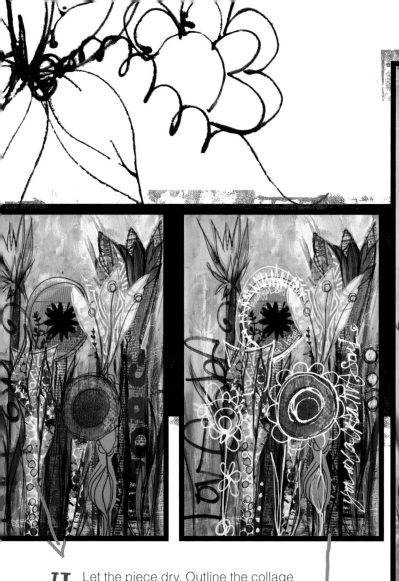

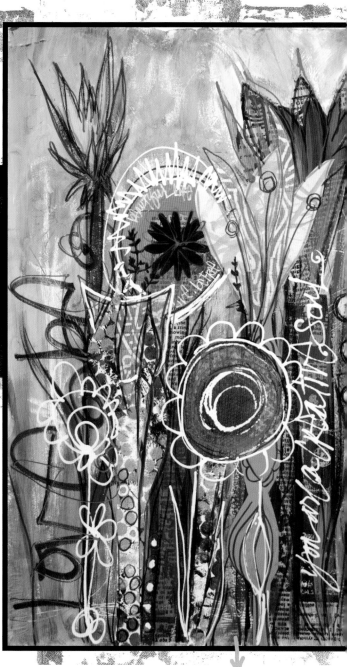

4 Let the piece dry. Outline the collage shapes with markers.

5 Doodle around the flowers and collage shapes with a white correction fluid pen and a solidified paint marker.

6 Doodle with dimensional fabric paint and outline the flowers and words.

DIGITAL MERGED LAYERS

Being trained as a graphic designer, I enjoy creating art by hand, then digitally enhancing it. I employ a number of ways to digitally alter my art, including using Photoshop and various iPhone apps like Hipstamatic, Pictureshow, Instagram and ArtStudio. The programs instantly alter photos by blending layers to create amazing effects. Explore how you can digitally enhance your art!

DIGITAL ART JOURNALING

I combine my photos with elements from my digital art journaling that include digital brushes, stamps, overlays, hand-lettered words and backgrounds, all created from my mixed-media paintings. I use a Wacom Bamboo Craft pen tablet to digitally scribble words and journal over my photos.

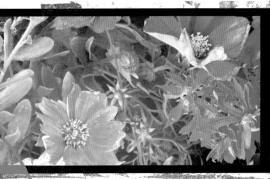 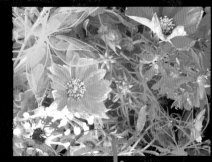 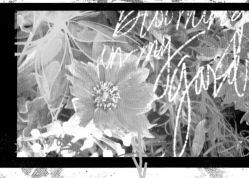

Layer 1: A photo of my garden taken with the iPhone Hipstamatic app opened in Photoshop

Layer 2: Digital floral stamps from my *Doodles Unleashed* digital brush kit (www.treicdesigns.com)

Layer 3: Final image with layers of digital stamps and journaling written with a pen tablet

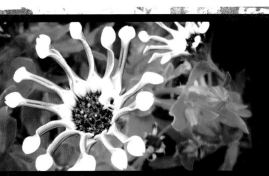 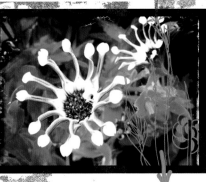 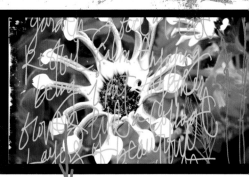

Layer 1: Hipstamatic photo opened in Photoshop

Layer 2: Digital kit brush of flower doodles stamped over the photo

Layer 3: The final image with journaling written with a pen tablet over the top of the photo

66

Digital Photo Layers

Tell stories with the images captured with your camera. Digitally merging photos on the iPhone is an interesting way to document your daily journey. The ArtStudio app provides a simple way to layer photos with blending modes. Create visual stories with the images you capture.

These three photos tell the story of a day in my creative life, capturing my painting table, collage idea board and the time I spent in my garden. The photos were taken with the Hipstamatic iPhone app:

Camera settings—Lens: John S; Film: Blanko Noir; Flash: off Photo of a transparency monoprint on the studio table

Camera settings—Lens: Buckhorst H1; Film: Blanko; Flash: off Photo of painted collage cutouts

Camera settings—Lens: Kaimal Mark II; Film: Ina's 1969; Flash: off Photo of flowers blooming in my garden

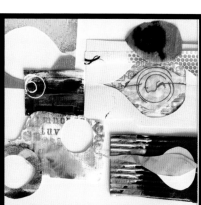

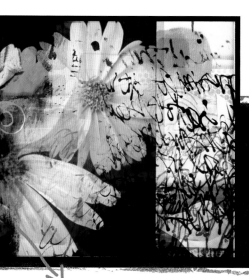

The final image with photo layers blended in iPhone ArtStudio app

The final image enhanced with Instagram Earlybird filter

EXERCISE: DIGITAL MERGED LETTERS

This piece is a combination of layers of a painted background of doodles and a hand-drawn letter. It was altered and created in Photoshop. I took photographs of two different pieces of artwork and layered them in Photoshop, then blended the layers with different filters.

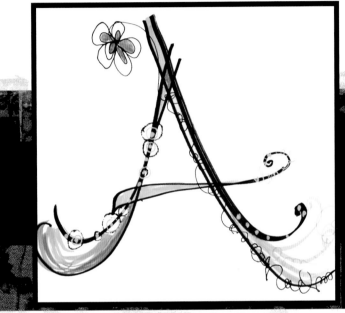

1 Create a unique hand-drawn alphabet. Draw the outline of letters with a black chisel-tip permanent marker. Fill in the letters with markers and gel pens, alternating colors. Have fun—make them colorful. Add doodles and dots to accent the letters. Add flowers or swirls to the ends of the letters.

2 Scrape a couple of colors onto a paper with a plastic tool (like an old hotel room key). Layer different markers, gel pens and pencils. Add collage pieces and doodles.

CREATIVE TOOLBOX

ADOBE PHOTOSHOP

BLACK CHISEL-TIP PERMANENT MARKER

PEN TABLET (WACOM)

PHOTO OF ALPHABET LETTER

PHOTO OF PAINTED OR COLLAGED BACKGROUND

PLASTIC SCRAPING TOOL, SUCH AS AN OLD HOTEL ROOM KEY

3 Take photos of your artwork from Steps 1 and 2. Import the images into Adobe Photoshop. Import the painting image from Step 2 as the bottom layer. Create a new layer and import the letter image from Step 1.

4 Create a third new layer and select the brush tool. Draw the Letter "A" in white. I prefer to draw with a pen tablet, which is more precise than using a mouse or trackpad.

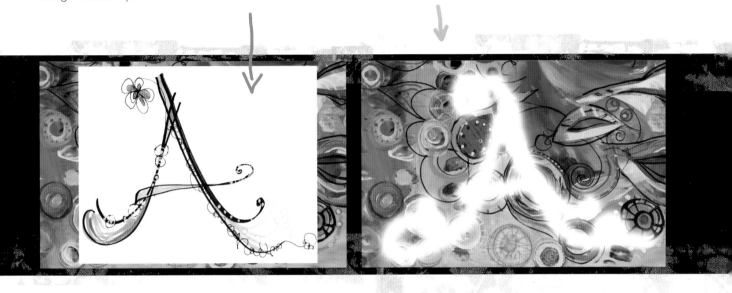

5 In the Levels window, change the blending mode to Multiply, which causes the levels to blend into one. Experiment with different layer adjustments like Overlay, Color Burn, Linear Dodge, Vivid Light or Difference. Each will create a different effect.

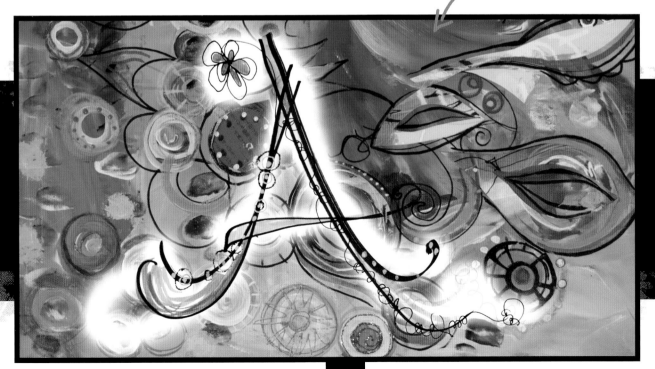

a drag of the brush...a scrape of paint...a dip of the pen nib into ink...a scribble... a zig-zag...a swirl of the pen...a smiley face with a crayon...all of these are the beginnings of unique marks. It's that simple....

A doodle can be a mark, a scribble or a drawing created aimlessly and freely, without care. It's not that doodles don't have meaning—because a lot of times they do!—but for the most part, they are unplanned, spontaneous marks that are often drawn subconsciously. In this chapter, we will focus on making unique marks through doodling.

Unique marks are born whenever you put a pen to a piece of paper, but they are not limited to handwriting or drawing. A mark becomes unique based on the tools you use to make it, the inspiration behind it and the surface it is made on. When doodling, I use traditional mark-making tools like paint pens, correction fluid pens, dimensional paint and permanent markers, as well

My doodling process is random and scattered. I'll work on multiple pages a day, adding a small bit to each page. I might scribble on a page with colored pencils, stamp paint on another page, and then go to a different page and doodle with black pens or write with a dip pen and sumi ink. I add elements of collage and draw a lot of faces, including my signature "girlie glam" doodles (see page 92) and my more stylized "fashionista" faces (see page 100).

There are so many ways to create unique marks that are inspired by everyday items and things we see in our travels and in daily life. Discover new and alternative ways to use tools and mediums and make your mark!

MAKING UNIQUE MARKS

as nontraditional tools like bamboo skewers, old hotel room keys, craft sticks and sponges. Each tool produces a distinctive result.

COLORED PENCIL DOODLES

My love affair with colored pencils started in my high school art class. I remember creating a large drawing of a model from a fashion magazine using only colored pencils. I loved the way I could blend them to create customized colors. I incorporate colored pencils in many of my doodles, paintings and art journal pages. They can be used over most painted or porous backgrounds, including fabric. Colored pencils give me more control over a detailed drawing than a brush does. Blending them gives an airy quality to the piece.

EXERCISE: BLENDING COLORED PENCILS

The beauty of the colored pencil is in its ability to create blended colors and create vibrant marks over paint. It's a great medium for adding bright color to doodles. My personal technique is to use a very "hard hand," applying a lot of pressure as I color. I like the waxy finish that results when the pencils are blended with more pressure. Use this exercise to practice layering and blending color.

CREATIVE TOOLBOX

1" (2.5CM) FLAT PAINTBRUSH

BLACK .035 PEN (COPIC MULTILINER)

COLORED PENCILS (PRISMACOLOR)

FLUID ACRYLIC PAINT (MATISSE DERIVAN)

INDIA INK (SPEEDBALL)

PLASTIC SOUFFLÉ CUP

SIZE 1 LINER PAINTBRUSH

SURFACE TENSION BREAKER WATERCOLOR AND AIRBRUSH MEDIUM (MATISSE DERIVAN)

140 LB. (300GSM) MIXED-MEDIA PAPER (STRATHMORE)

1 Paint a piece of mixed-media paper with fluid acrylic paints. To create a wash of color, dip your brush into water and mix it with paint. Drizzle surface tension breaker medium over the surface and move the paper around in different directions, letting the medium flow over the page. Add another color for contrast.

2 Paint a flower or abstract design using a size 1 liner paintbrush dipped into India Ink.

3 Begin to fill in the painted design with colored pencils. Choose five to seven colors for a piece of artwork and use those throughout the painting to create a balanced composition. Experiment blending with three analogous colors, like lime green, turquoise and yellow. Start with one color, then add the next over the edge of the last until the drawing is filled in. Work in different areas of the piece, in no specific order.

4 Use a white colored pencil to blend the colors together and create tints of colors. Color lightly over the first layer of colored pencil marks.

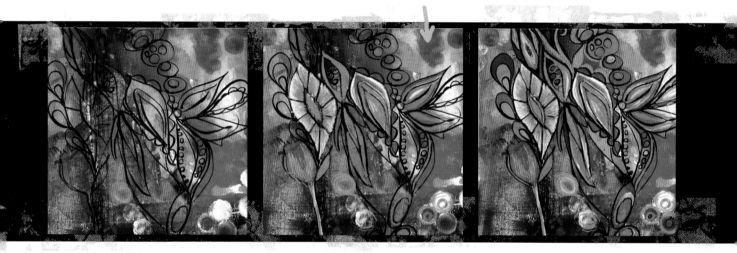

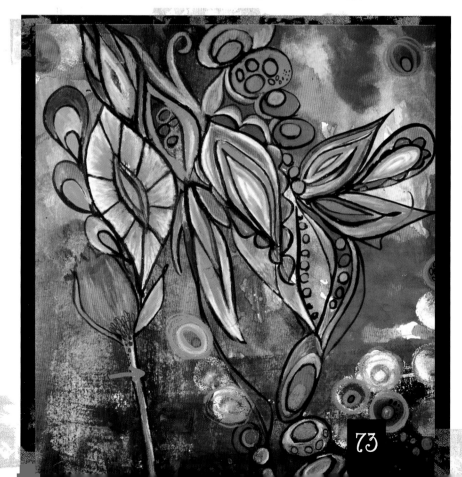

5 Use a black .035 pen and clean up the edges of the design. This adds a nice sharpness to the finished piece.

PIPETTE DRAWINGS

The pipette is a great drawing tool. It creates beautiful lines and drips of paint depending on how it is used. There is a slight learning curve when working with the tool. You will need to lightly squeeze the ink out by pressing the top while dragging it across the page to create a design. Here are two different ways to incorporate pipettes into your doodling.

EXERCISE: PIPETTE FLOWERS

One of my favorite recurring themes within the pages of my journals and in my inspiration photos is flowers. I love painting, stamping and creating abstract floral shapes. This exercise focuses on beginning with a pipette doodle.

CREATIVE TOOLBOX

COLLAGE PAUGE

COLORED PENCILS (PRISMACOLOR)

FOAM BRUSH

PLASTIC PIPETTE

WATERCOLORS (SAKURA KOI)

WATERPROOF INDIA INK (SPEEDBALL) OR SUMI INK

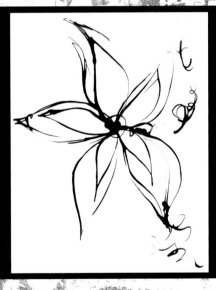
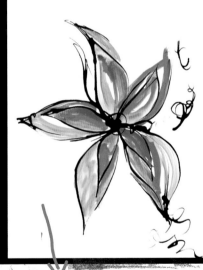
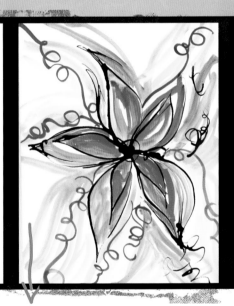

1 Prepare the pipette with waterproof India or sumi ink. Squeeze lightly as you draw a flower shape.

2 Make sure the ink is completely dry before you paint over it or it will smear. Paint the inside of the flower with watercolors or an acrylic wash.

3 Continue to add color and doodles around the flower and accent inside the flower with colored pencils.

Tip

Keep the tip of the pipette on the surface as you draw to control the weight of the drawn line.

TIP

Work fast as you write so the ink doesn't
create a large puddle on the piece.

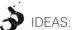 IDEAS:
- Draw flowers, birds or trees, or write words.
- Experiment by collaging black-and-white photocopies over the pipette doodle and painting acrylic washes over the collage, letting the text show through.
- Try doodling on different surfaces, especially painted backgrounds—they make great jumpstarts.

4 Cut out leaf and petal shapes from hand-painted construction paper, and collage them over the top of the doodled flower. Adhere the cut pieces with Collage Pauge or your favorite gel medium. Be sure to apply a layer of medium under and over the collage pieces. Smooth the pieces out with your finger to prevent air bubbles.

5 Outline the collage pieces with waterproof India ink applied with a pipette.

EXERCISE: PIPETTE DRAWINGS ON TISSUE COLLAGE

Finding the doodle in a painted background takes a little creative visualization. Turn your paper in various directions and look at the shapes. What do you see? Begin to call out those shapes by making marks with a pipette and ink.

CREATIVE TOOLBOX

1" (2.5CM) FOAM BRUSH

BLEEDING TISSUE PAPER

"CLEANUP" PAPER

COLLAGE PAUGE

GESSO

OIL PASTELS (SAKURA SPECIALIST)

PAINTBRUSH

PLASTIC PIPETTE

SUMI INK

WATER BRUSH

WATERCOLOR PENCILS (DERWENT INKTENSE)

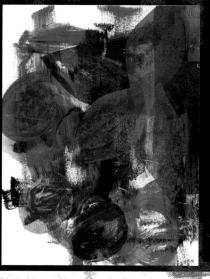

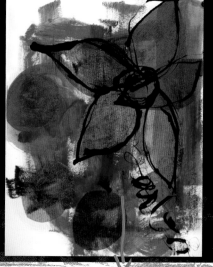

1 Collage pieces of bleeding tissue paper into flower shapes over a piece of "cleanup" paper with Collage Pauge.

2 Fill a plastic pipette with sumi ink. Drizzle ink onto the page, tracing the flower shape. Squeeze the pipette gently to slowly release the ink. To prevent large puddles of ink from forming, touch the tip of the pipette to the page and move across it slowly.

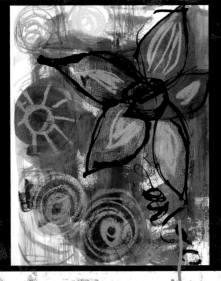 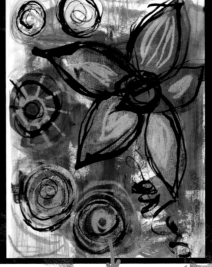 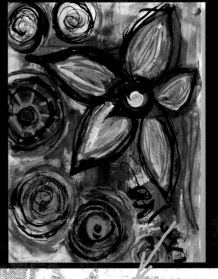

3 Make marks with oil pastels, coloring the background and inside the flower.

4 Scribble on the piece with watercolor pencils and spread the colors with a water brush. While the sumi ink is wet, use a brush to draw more doodles.

5 With a foam brush, paint gesso over the wet surface to accent the doodles. The gesso will tint when it is painted over colored tissue paper.

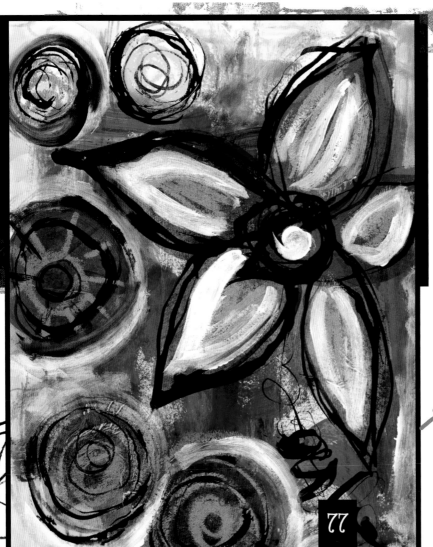

6 Blend wet gesso with watercolor pencils, using a paintbrush to add tints of color to the page.

COLLAGE PAUGE TECHNIQUES

Collage Pauge is not only an adhesive; it is also a painting medium. It can be mixed with paint for a glossy shine or used as a clear resist. I like to doodle lines and draw with Collage Pauge in a fine-tip applicator bottle.

EXERCISE: COLLAGE PAUGE RESIST

Make unique marks by drawing with Collage Pauge. Dried adhesive will act as a resist when you paint over it. Write words, doodle and draw, let it dry, then paint a wash to reveal the marks.

CREATIVE TOOLBOX

140 LB. (300GSM) VISUAL
JOURNAL WATERCOLOR
PAPER (STRATHMORE)

COLLAGE PAUGE GLOSS

FABRIC CROCHET DOILY

FINE-TIP APPLICATOR
SQUEEZE BOTTLE

SHIMMERING MIST SPRAYS
(LUMINARTE RADIANT RAIN)

WATER BRUSH

1 Transfer Collage Pauge Gloss into a fine-tip applicator squeeze bottle. Write words and phrases, scribble designs and make marks by writing with the applicator bottle on the surface of the paper. Let it dry. Spray through a fabric crochet doily with a couple colors of shimmering mist sprays. Let them dry.

2 Paint a wash of color by spraying two shimmering mist sprays onto a palette, then painting them onto the page. The Collage Pauge will act as a resist, and the paint sprays will slightly dye the Collage Pauge to cause a "ghosting" effect. The ghosting effect allows you to see the writing when you tilt the page in different directions.

EXERCISE: COLLAGE PAUGE GLITTER DOODLES

Add a little bling to your painted creations! Another great technique for Collage Pauge is to create clear dimensional lines and marks over painted designs. Play with doodling over your painted creations and adhere various glitters, mica powders or foils that will add texture to your art.

TIP

Try this technique on fabric or wood.

CREATIVE TOOLBOX

A VARIETY OF ULTRA-FINE GLITTERS AND VINTAGE GERMAN GLASS GLITTERS

CARDBOARD OR ANY PAPER OR FABRIC SURFACE

COLLAGE PAUGE

DOODLE PRINTING PLATE (SEE PAGE 9)

FINE-TIP APPLICATOR SQUEEZE BOTTLE

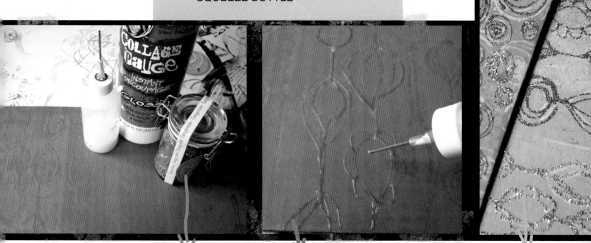

1 Place Collage Pauge into a bottle with a fine applicator tip.

2 Use a doodle printing plate (see page 9) to apply a design to a piece of corrugated cardboard. Trace over the doodle design with Collage Pauge.

3 Sprinkle glitter over the piece.

STYLISTIC SCRAWLS

scrawl (skrôl) v. scrawled, scrawl·ing, scrawls to write hastily or illegibly.

Creating stylistic scrawls is something that I have practiced since I was young. The combination of my mark-making tools and my personal graffiti creates my own unique brand of stylized writing. I use all kinds of tools to write with: pens, permanent markers, crayons, colored pencils, highlighters, Chinese paintbrushes, glitter paint or acrylic paint in a fine-tip applicator, glue pens and bleach pens. I also use found tools like eyedroppers filled with India ink, cut-up craft sticks, chopsticks and feathers—anything I can dip into ink or make marks with.

As I write, I rotate my painting or art journal in different directions, spilling my thoughts, feelings and ideas onto the page. I write in a circular direction or in a heart shape. I draw lines and then write in between them, overlapping my words to disguise my thoughts. Sometimes the words are illegible. Sometimes they are simple and plain. My journal tells a visual story with lines, scrawls and scribbles. Journaling is all about expressing yourself through images and words and writing whatever comes to mind.

Stylistic scrawls will look different for everyone. Start doodling words and phrases in your journal or on paper, napkins or fabric—anything you can write on. As you work, ask yourself, "What if I tried this?" and "I wonder if this would work?" Try adding swirls or flourishes to the ends of your letters. Make an outline of a letter and fill it in with more doodles. Write words, letters or phrases that are layered on top of each other to create interesting effects. Play a word-association game and write words as you think of them. If you get stuck, find a font that you like and try to copy the strokes. What are your favorite tools, mediums and pens? How can you combine them to make a stylistic mark unique to you? Practice developing your style by experimenting with different lettering styles using your favorite mark-making tools.

Don't be afraid! You can't make a mistake, because you are developing your own style. Just relax, have fun and play!

Create brush washes on a piece of paper or muslin (or both!). Dip your brush in ink or watered-down acrylic paint and paint strokes across your surface. Let the wash dry. Use a felt pen to accent the paint wash.

CREATIVE EXERCISE
BRUSH WASHES

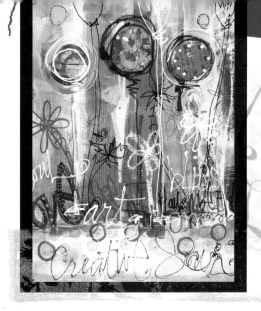

These stylistic scrawls were made on a manila folder. Scrape paint or stamp patterns in the background of the folder, then layer stylistic scrawls with pens and markers. Add flower doodles. Collage colored photocopy paper circles onto the piece, then add more doodles.

WATCH IT!

GO TO WWW.CREATEMIXEDMEDIA. COM/DOODLES-SCRIBBLES TO WATCH A TECHNIQUE VIDEO ON STENCILING, STYLISTIC SCRAWLS AND DIMENSIONAL GRAFFITI SCRIBBLES.

GRAFFITI-INSPIRED STYLISTIC SCRAWLS

In some of my artwork, I experiment with lettering styles inspired by urban graffiti walls. I make these graffiti scrawls my own by adding doodles to the letters, layering scribbled graffiti or writing with glitter dimensional paint. The movement of my marks, the overlapping of the words and the repetitive style of the letterforms define these graffiti-inspired stylistic scrawls as mine.

DIMENSIONAL GRAFFITI SCRIBBLES

I love puffy paint! Using it in my art is a throwback to my days as a cheerleader and sorority member when I used it to design one-of-a-kind t-shirts. Now, I use it to doodle on top of painted fabrics and to embellish my collage paintings and journal pages.

Use dimensional paint to doodle over stencil prints (see page 54), highlighting different shapes. Write words with the paint. Draw quickly when applying dimensional paint so it doesn't form large beads on the surface.

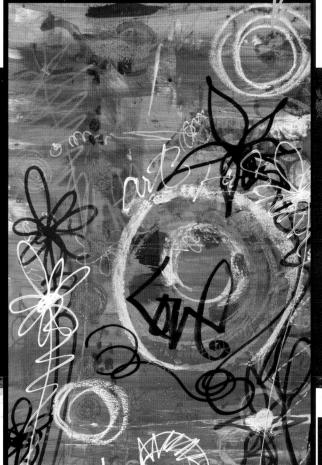

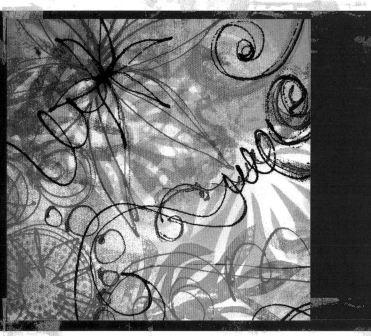

Layering Letters

This technique is inspired by the colorful abstractions of urban graffiti walls layered with vibrant colors, peeling textures and words, and can be translated to create interesting backgrounds for collage or paintings. Create your own graffiti-style mixed-media layered backgrounds over cleanup paper, painted fabric or collage. This exercise is a great way to overcome the blank page. Write your thoughts, scribble words and make marks.

IDEAS:
- Use a magazine, newspaper or book as inspiration.
- Graffiti wall: Place a large piece of paper on the wall and add marks to it daily. Cut the large paper smaller to use for journal pages.
- Alternate the size, color and type of letter.
- Experiment with different mark-making tools to create interesting lines.
- Create graffiti canvases by using fabric as the base.
- Spray through letter stencils, then add your own lettering.

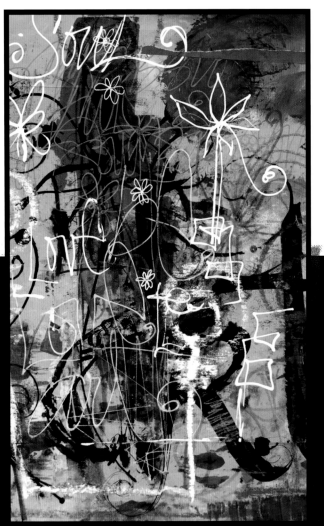

CREATE A "CLEANUP" PAPER

Place a large piece of brown craft paper, white butcher paper or a manila folder over your work surface to catch all your excess paint and marks while you are creating. Write over a cleanup background paper with various markers and a white correction fluid pen.

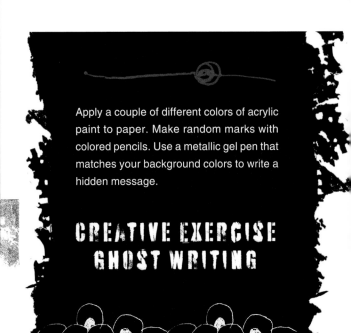

Apply a couple of different colors of acrylic paint to paper. Make random marks with colored pencils. Use a metallic gel pen that matches your background colors to write a hidden message.

CREATIVE EXERCISE GHOST WRITING

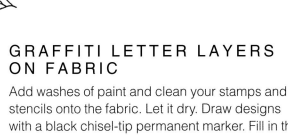

GRAFFITI LETTER LAYERS ON FABRIC

Add washes of paint and clean your stamps and stencils onto the fabric. Let it dry. Draw designs with a black chisel-tip permanent marker. Fill in the doodles with various colors of oil pastels, markers and gel pens. Add some phrases and words with fine-nib markers. Turn the fabric in another direction and continue to write. For fine black lines, a Pilot Tough Wash pen or black permanent marker works well.

A great exercise to get your writing going is to write randomly on a large piece of paper or canvas. Stain the background with a few different colors of paint. Let it dry. Then write whatever comes to mind with a permanent pen. Alternate pens and nib sizes to create letters in varied weights. Use a black pen for more contrast. Try using gel pens over the paint, too. For a watercolor look, write with felt pens.

CREATIVE EXERCISE RANDOM WRITING

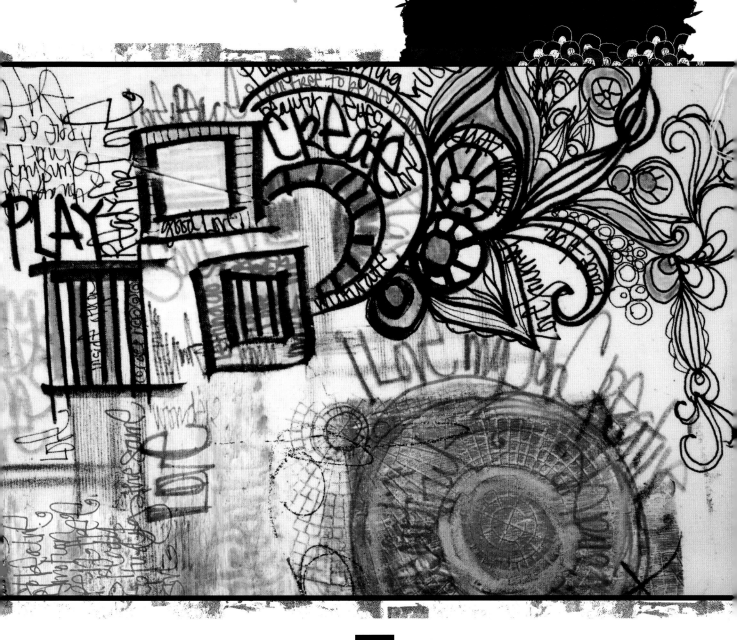

COPIC LAYERS PAINTING

Many of my paintings are visual stories with minimal words, but there are also times when I want to spill my thoughts and express my feelings on the page. These words and letters are layered over each other—sometimes legibly and other times not—but the lines tell a visual story with their movement and color. I use various pens and markers to write about my day, thoughts and aspirations, or how I feel at any given moment. I alternate my writing by working in different directions on the page and using different markers to sometimes disguise my words. Experiment with layering different Copic markers and pens to form your own visual poetry.

Work by alternating the pens, markers and pencils that you use for doodling. Here are a few jumpstarts:

- Outline black lines and shapes with metallic pens.
- Use red marker over yellow paint for contrast.
- Add dark lines with a black chisel-tip permanent marker.
- Write a few words about your day.
- Add circles with a white correction fluid pen.
- Outline circles with glitter pens.

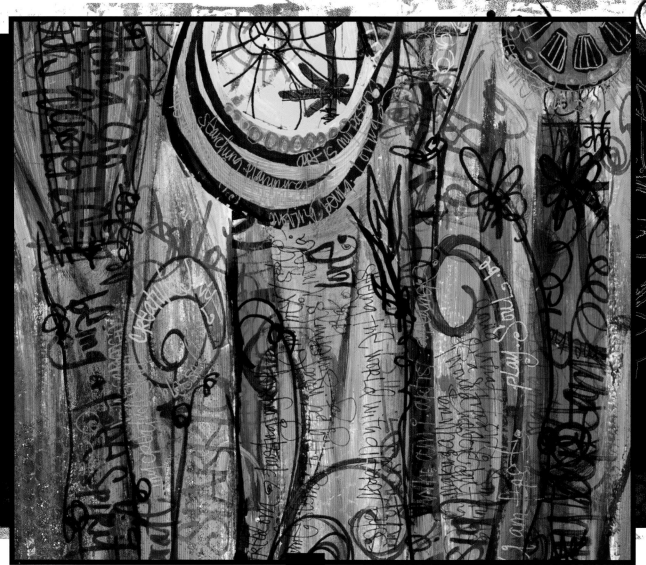

GRAFFITI MASTERBOARD

A graffiti masterboard is a painting you can use as a "master" to photocopy, scan and print. Photocopy it in color and use the pieces for handmade cards, scrapbook pages or ATCs. Masterboards can be theme-based using different colors, letters, words or phrases.

Paint a piece of heavy cardstock or 140 lb. (300gsm) watercolor paper. Print patterns with handmade stamps by applying paint to the stamp with a foam brush and pressing the stamp on the surface. Stain the page with watered-down acrylic wash. Let it dry. Then write over the top with various markers. For this masterboard I used permanent markers, a white correction fluid pen and Sakura Glaze and Soufflé gel pens. This example can be used for birthday, autumn and thank you cards.

 IDEA: Create a themed "holiday nouveau" masterboard, painting the background fuchsia, lime and purple. Then write phrases like *happy holidays*, *joy*, *merry* and *love* and stamp or stencil tree, ornament and wreath shapes. Create one master and photocopy it multiple times. Cut out pieces of the photocopies and stitch them onto holiday cards or make mini journals. Print the design on inkjet fabric sheets or iron-on transfer sheets and make an art-quilt stocking.

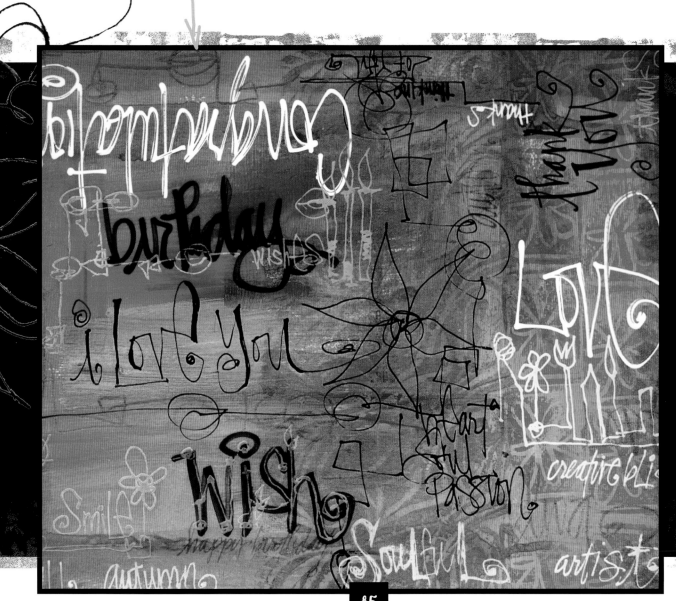

EXERCISE: CONTINUOUS WRITING

Writing lists and scribbling quotes are fabulous ways to write continuously. Play with different tools as you write to build up layers of color. I use this technique to make creative layers of text that, in the end, look like abstract lines.

CREATIVE TOOLBOX

1" (2.5CM) FOAM BRUSH

BLACK, BLUE AND GREEN PERMANENT MARKERS (SAKURA PIGMA SENSEI)

BLUE INK (LIQUITEX)

DIMENSIONAL FABRIC PAINT (TULIP SLICK)

GREEN AND WHITE ACRYLIC PAINT

HIGHLIGHTER

MARKERS WITH BRUSH AND CHISEL TIPS (COPIC)

METALLIC MARKER (SAKURA PERMAPAQUE)

PAINTASTIC BRUSH PEN AND MAGIC WAND (ELMER'S)

POSTER MARKERS

RED WIDE MARKER (COPIC)

WHITE CORRECTION FLUID PEN

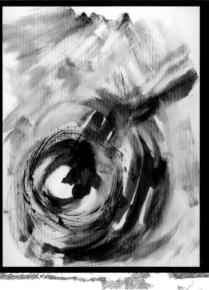

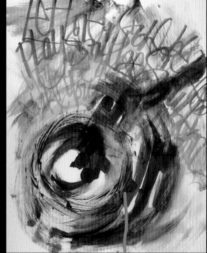

1 Paint a background with green and white acrylic paint. Dip the brush corners into two different colors and mix the paint on the paper as you brush it onto the surface. Place a little bit of blue ink on a brush and brush it into the wet paint. This will darken areas on the background. Let the paint dry.

2 Write words and phrases using two different colors of markers with brush and chisel tips.

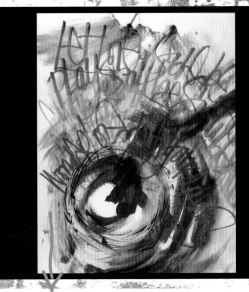 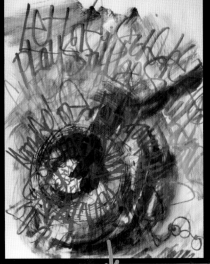 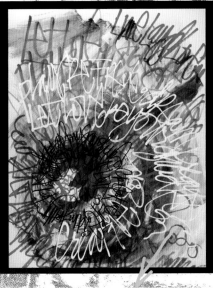

3 Continue writing around the circular painted design with a metallic marker.

4 Add contrast color with a poster marker and blue and green permanent markers. Scribble more words with a Paintastic Brush Pen and Magic Wand to create variegated colored letters. Write with a highlighter to create transparent letters. The highlighter will blend with the color it is written over.

5 Brighten up the page by writing with a red wide marker and a white correction fluid pen over the previous layers. Add contrast with words scribbled in black permanent marker.

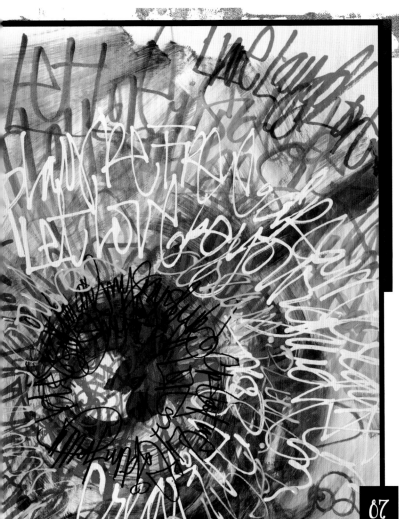

 6 Add a layer of textured letters by writing with dimensional fabric paint.

TIP

Experiment with creative lettering on fabric. Grab a piece of muslin and a few markers and make marks and scribbles by writing in layers, switching colors as you work. Paint the fabric with foam or fabric brushes. Create a watercolor effect by loading a little water and paint on the brush.

PATCHWORK FREEMOTION LETTERS

Doodle and write with your sewing machine! Freemotion lettering is a great way to embellish your art. After a little practice, you can create a unique personal lettering style with stitches. You need a sewing machine where you can drop or lower the feed dogs. Once you set up your machine and change your sewing foot to a darning or freemotion foot, you are ready to go.

FREEMOTION STITCHED LETTERS

Set up your sewing machine for freemotion stitching. Refer to your manufacturer's sewing machine manual to find out how to do this. Pull the fabric through the machine using the same motion you'd use if you were writing the letters over the top of the fabric.

TIPS

- Make sure your paint and glue is completely dry before you attempt to sew. Practice sewing doodles and letters on scrap fabric.

- Stitch along the lines and doodles of your background.

- Choose thread colors that contrast with the painted background, so they will pop off the surface and not blend with the background. For example, if you have a turquoise background, choose a bright, fire-engine red thread.

- Experiment with different types of thread. I prefer two different colors and types of thread: rayon for the top thread and cotton for the bobbin. I use rayon for the top because it creates a bright and shiny finish.

- Alter the speed of your machine to a comfortable pace so you can sew legible letters.

- When starting out, keep the machine speed slow to get comfortable with moving the fabric.

- If you use a lot of glitter in your artwork and stitch over the pieces, be sure to give your machine a good cleaning afterward to remove all the dust and particles.

Create a patchwork art quilt collage background by freestyle stitching pieces of hand-painted fabrics together. To create a quilt, pin together the top painted fabric to a piece of bamboo batting and a backing fabric and stitch. Note that these fabrics were printed with letter stencils and needlepoint canvas. See the Stencils technique on page 54.

STYLIZED FACES

Throughout the years, I have developed my signature style of drawing faces, which I call "girlie glam" faces. These unique drawings are created with a mix of pens, paint markers, ink, acrylic paints and colored pencils. Some start with a doodle on a plain piece of paper or fabric. Others are painted over a collage base or fabric.

My "fashionista" faces are inspired by fashion photography. I scour through magazines to find inspiration from photos of models' faces and poses to incorporate into my designs. I use the photos as guides for face shapes and shading.

ACRYLIC, PAINT PENS AND COLORED PENCILS

Draw an outline of a face on a brown paper bag. Fill in the face with two colors of paint. Let it dry. Draw more details over the painted face and add lines for hair with a black fine-tip oil-based paint marker. Brush on contrasting colors of paint. Accent the drawing with colored pencils.

ACRYLIC, COLLAGE AND PAINT PENS ON ILLUSTRATION BOARD

Create a patchwork collage on illustration board. Paint a shape for the face with a mix of white and green acrylic paint over the collage background. Let it dry. Draw a quick outline of a face with a black fine-tip oil-based paint marker. Fill in the design with contrasting paint colors. Add more detail with a black pen. Draw over the painted design with various colored oil-based paint pens. Highlight shapes in the background with colored pencils.

REMNANTS ART QUILT JOURNAL

Create a wash by dipping a paintbrush into water, then into Golden fluid acrylic paint. Brush wash onto hot-press watercolor paper. Wash another color onto the surface. Brush paint onto a craft foam stamp and press it onto the paper to create a pattern. Let it dry. Draw a face over the painted background with a 0.35 black permanent pen. Thicken areas of the outline with a broader black permanent pen. Fill in the outline by mixing various colored pencils on the surface. Color with a heavy hand to yield more opaque coverage.

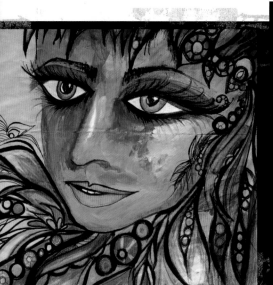

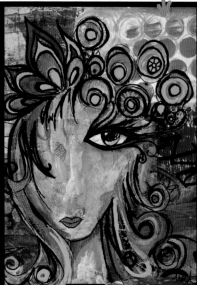

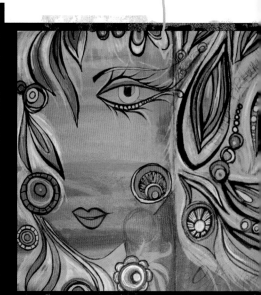

This face was painted on a fingerpainted background. Black and colored Sharpie oil-based paint pens were used to draw the girlie glam face. I then added accents with Prismacolor colored pencils and a correction fluid pen.

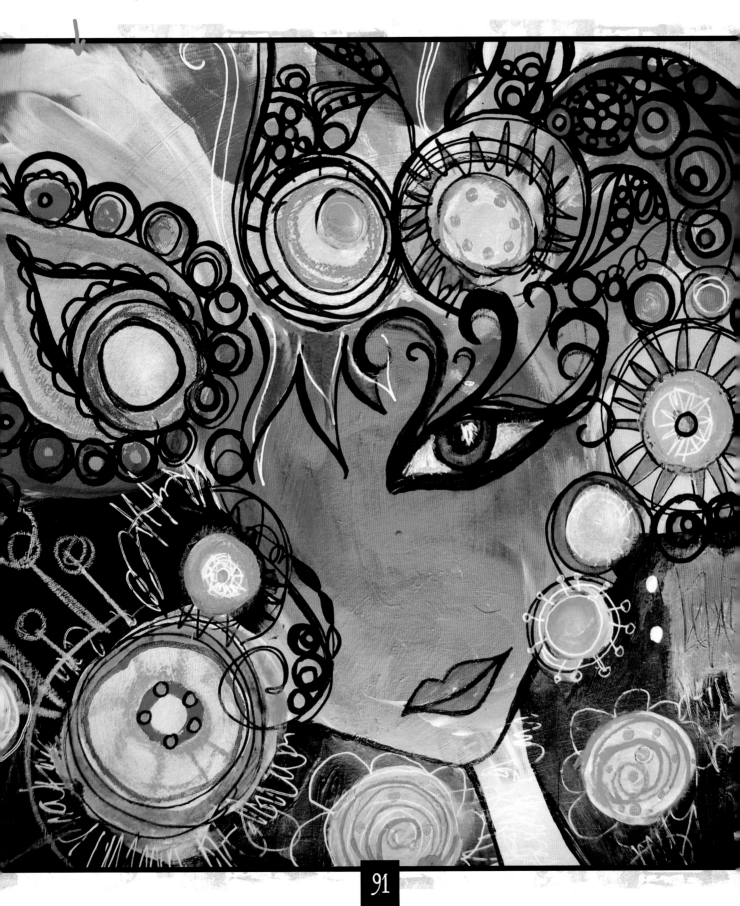

GIRLIE GLAM FACES

I find myself constantly doodling faces. Usually, my signature girlie glam girl has one eye and wildly drawn hair or a headdress. I can sit and draw different variations for hours. I don't have a plan; I let the pen move around the page, embellishing the hair and eyes, making marks and outlining previous marks.

In order to discover your own style of character or face, you must practice. Use the girlie glam doodles below as inspiration to jumpstart your drawings. Study the lines and shapes. Begin by drawing the eye and mouth. Next, draw a chin and neck. Then, add lines and abstract shapes for hair. Thicken the lines with color for more detail. Remember to add your own style!

IDEA: Create a journal or sketchbook dedicated to drawing faces. Draw one face a day.

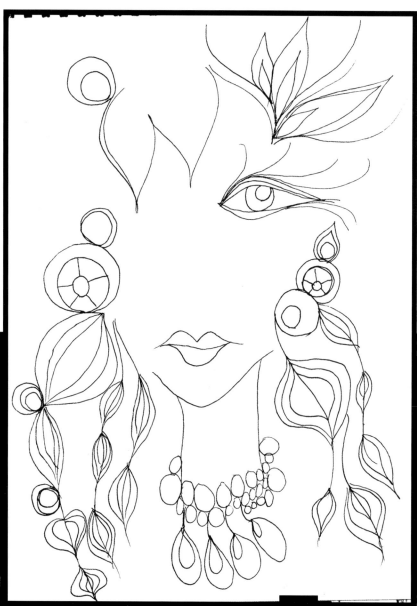

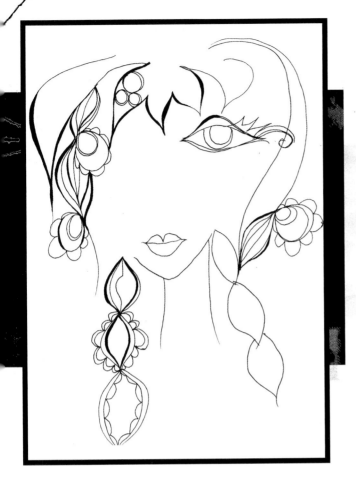

DOWNLOAD IT!

GO TO WWW.CREATEMIXEDMEDIA.COM/
DOODLES-FACES TO DOWNLOAD FULL-SIZE
FACES TO PRACTICE WITH. TRACE, DOODLE,
EMBELLISH AND USE THESE DOWNLOADS AS
A GUIDE FOR YOUR OWN GIRLIE GLAM FACES.

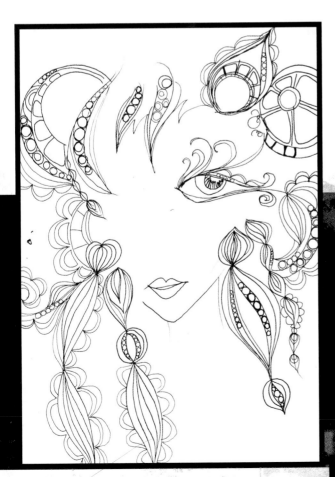

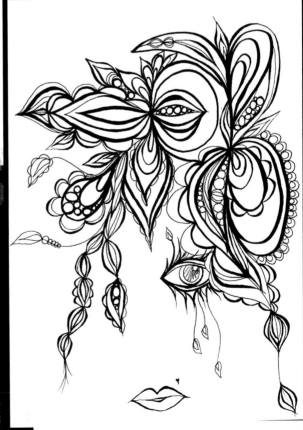

DEVELOPING YOUR SIGNATURE STYLE

What images do you continue to draw over and over in your artwork? What style of art do you make? What types of lines do you draw? Is there a pen or a brush that you like to use? If you continuously make unique marks as you paint and draw, over time you will create your own signature style.

Practice . . . practice . . . practice creating your signature style faces, drawing the images many times. As you become familiar with the lines, drawing the faces will become second nature. Experiment with your favorite tools and add your personal touch with doodles and color.

My method of drawing stylized faces is similar to that of most of my paintings. I start with a simple drawing of a face on a surface. They are drawn on paper, fabric and handmade canvases. Some of the faces drawn on fabric are stitched into journal covers or tote bags, or become the main panel for an art quilt wall hanging. Below are a few examples of faces I have drawn on nontraditional surfaces.

ART QUILT

Draw a girlie glam face on a piece of drill cloth with a permanent fabric pen. Write words and doodle flowers in her hair. Stitch the drawing onto various fabrics to create an art quilt.

JOURNAL COVER

Use the fabric from a pair of worn-out jeans as a background for a drawing. Stitch the fabric onto a heavyweight shipping envelope to make a sturdier cover. Draw a face with a black permanent marker.

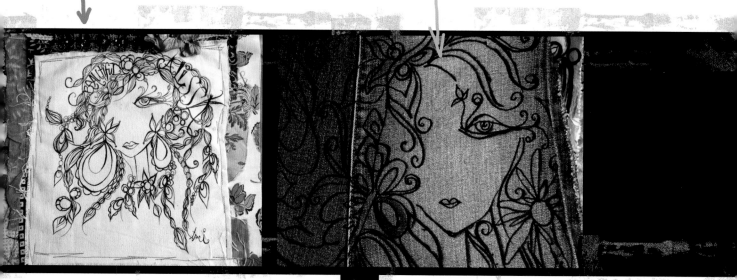

GIRLIE GLAM BRUSH DOODLES

The tools you use to draw your faces will yield different results. One of my favorite tools is a fine-tip round brush dipped in sumi or India ink. Draw the face as you would with a pen, but use a brush instead. It takes practice, but you can master it!

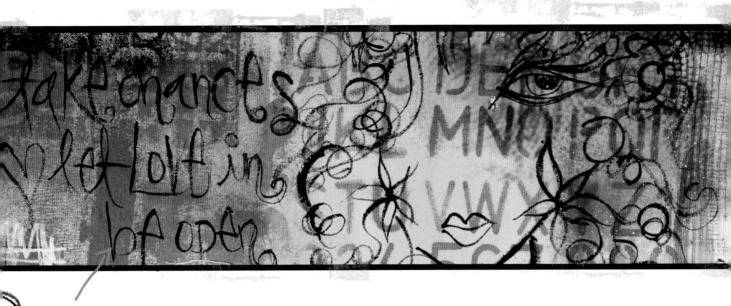

This girlie glam brush doodle was painted on a piece of painted drill cloth. The background is one of my graffiti canvases covered with layers of fabric paint sprayed through stencils and designs printed with transparency monoprints. It is then layered with scrapes of paint. I used sumi ink to doodle over the top of the dried paint.

I used a photo from a fashion magazine to inspire this face painting. I quickly sketched out a face using ink and a brush.

This face was painted with a size 1 round brush using India ink on vellum bristol. The vellum bristol paper is a smooth surface and holds the ink well.

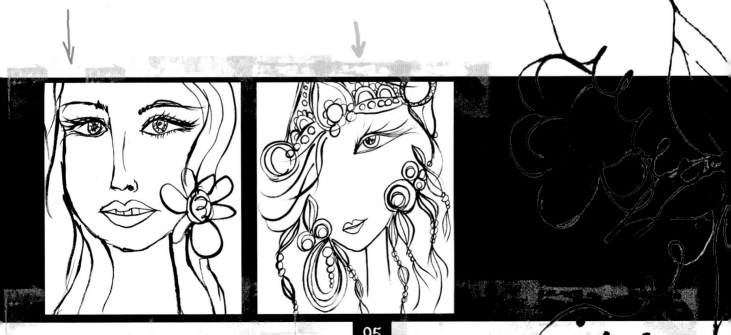

EXERCISE: GIRLIE GLAM DOODLE

Create a girlie glam painting on fabric! One of my favorite surfaces to draw on is unbleached muslin. I use the muslin right off the bolt. Play with layers of paint and build up the color with markers and soft pastels.

TIP

If you are creating art on a piece that will be worn, make sure to use fabric paints and markers.

CREATIVE TOOLBOX

BLACK PERMANENT PEN
(PILOT TOUGH WASH)

BRUSH-TIP FABRIC
MARKERS (TULIP)

COLORED PENCILS
(PRISMACOLOR)

FABRIC PAINT IN TWO
DIFFERENT COLORS
(TULIP SOFT)

METALLIC GEL PENS
(SAKURA)

OIL PASTELS
(SENNELIER)

PAINTBRUSH

PENS (COPIC)

PERMANENT MARKERS

SOFT PASTELS
(PANPASTEL)

SPONGE APPLICATOR

UNBLEACHED MUSLIN

WATERCOLOR PENCILS
(DERWENT INKTENSE)

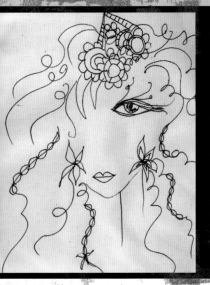

1 Iron the wrinkles out of a piece of muslin fabric. Draw a face with a Tough Wash pen. Note some of the features of the face: the hair with braids and flowers above her forehead.

2 Pour two different colors of fabric paint onto a palette. Dip a paintbrush into both paints. Apply the paint to the fabric in fast, wavy and circular strokes. Continue to add both colors of paint to the fabric until the hair is filled with color. Let the paint dry.

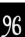

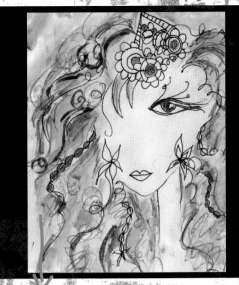
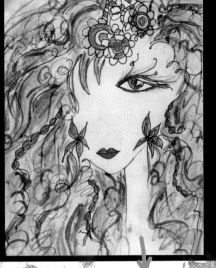
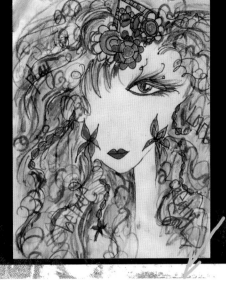

3 Dip a watercolor pencil into water and apply it over the paint to accentuate the lines in the hair. Scribble lines with colored pencils and color the braids with metallic gel pens. Doodle thicker lines in the hair using a brush-tip fabric marker.

4 Add hints of the colors throughout the hair with colored pens.

5 Add another color to the hair with a pen. Write words and phrases in the hair.

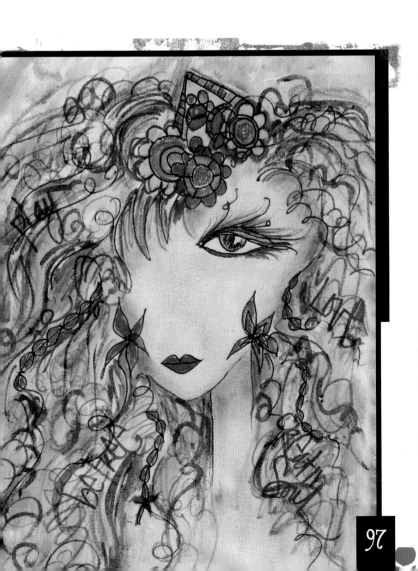

6 Color the face with soft pastels using a sponge applicator to evenly apply the color. Highlight shadows at the edges of the face using a darker oil pastel.

WATCH IT!

VISIT WWW.CREATEMIXEDMEDIA.COM/ DOODLES-GIRLIE-GLAM TO WATCH A STEP-BY-STEP VIDEO OF THIS EXERCISE.

EXERCISE: PATCHWORK COLLAGE GIRL

Patchwork collage is simple to create and makes a great background for doodling. I cut pieces of a variety of my hand-painted papers, graffiti tissue papers and photocopies and collage them onto a surface. Then I paint my doodles over the top. This is a great project to use all the remnant paper pieces in your stash!

TIP

When creating patchwork collage, cut pieces and work in small sections. Brush Collage Pauge onto the surface. place the paper, brush another layer of Collage Pauge on top and smooth it out with your fingers. Apply another layer of Collage Pauge and place another paper overlapped onto the previous one. repeat these steps. Apply a final layer of Collage Pauge over the entire piece and let it dry before you draw or stitch over the top.

CREATIVE TOOLBOX

ACRYLIC PAINT

BLACK-AND-WHITE PHOTOCOPIES

BLACK FINE-TIP OIL-BASED PAINT MARKER (SHARPIE)

BLACK PERMANENT MARKER

BROWN PAPER BAG

COLLAGE PAUGE

DYED PAPER TOWELS

GRAFFITI TISSUE PAPER (SEE PAGE 48)

MARKERS (COPIC)

PAINTBRUSH

PENS (COPIC MULTILINER)

SCISSORS

WHITE CORRECTION FLUID PEN

WHITE GESSO OR ACRYLIC PAINT

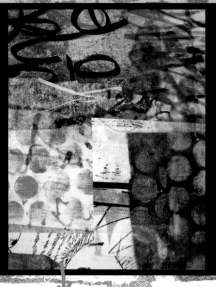

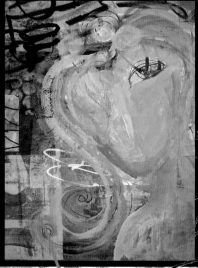

1 Layer photocopies, dyed paper towels and pieces of graffiti tissue paper using Collage Pauge to create a patchwork collage.

2 Mix white gesso or white acrylic paint with another color. Paint a face shape onto the collage. Paint a darker color to add shadows to the face. Add a third color to the hair. Let it dry.

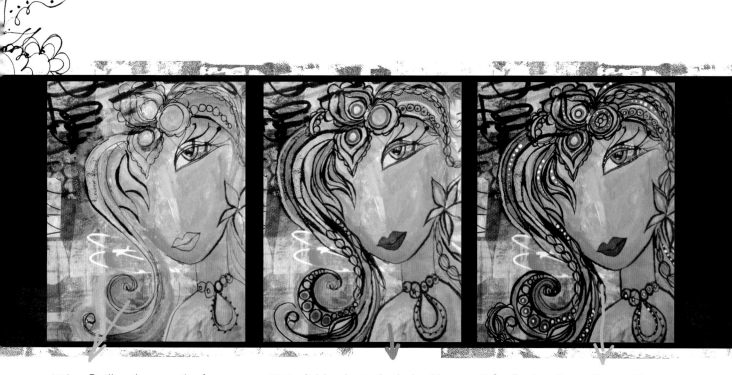

3 Outline the eye, the face and the hair with a black permanent marker.

4 Add color to the hair with paint pens, colored pencils and gel pens.

5 Darken the outlines with a black oil-based paint marker. Add dots and circles with a white correction fluid pen.

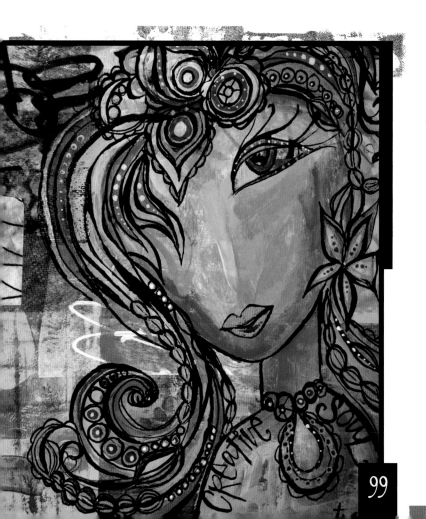

6 Write "creative soul" around the neckline with a black oil-based paint marker.

EXERCISE: FASHIONISTA PHOTOCOPIED FACE

Recycle, reuse, photocopy! One way to leverage your work is to paint over photocopies. The original painting below was a watercolor face sketch. This exercise guides you through using a photocopy of one of your painted face outlines as a base for a brand new piece.

CREATIVE TOOLBOX

ACRYLIC PAINT

BLEEDING TISSUE PAPER

COLLAGE PAUGE

COLORED PENCILS (PRISMACOLOR)

PAINTBRUSHES

BRUSH MARKERS (COPIC)

PHOTOCOPY OR DIGITAL DOWNLOAD OF FACE

TISSUE PAPER

WHITE GEL PEN (SAKURA)

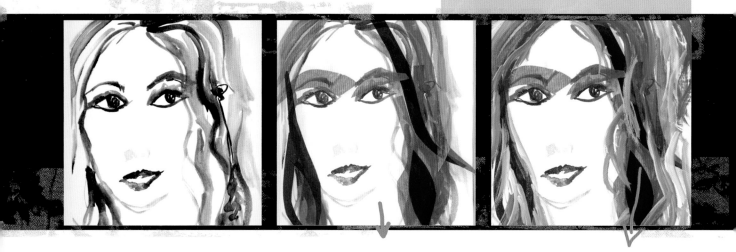

1 Make a black-and-white photocopy of one of your original face paintings to use as a base for the new painting.

2 Collage bleeding tissue paper onto the photocopy with Collage Pauge. This type of tissue paper will stain paper when it gets wet.

3 Use acrylic paints to paint the hair, blending the colors with white paint.

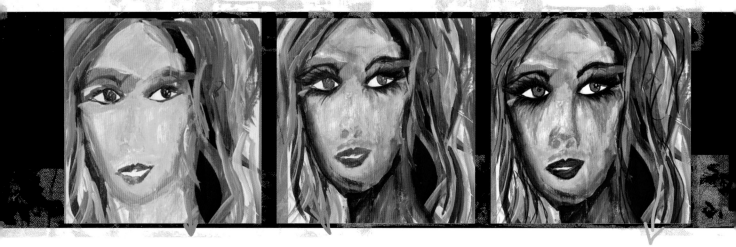

4 Paint the face with one color, and then add a slightly darker shade to highlight certain areas.

5 Add depth and contrast onto the face and eyes with a third color.

6 Using brush markers, add darker lines for the hair, eyebrows and eyelashes.

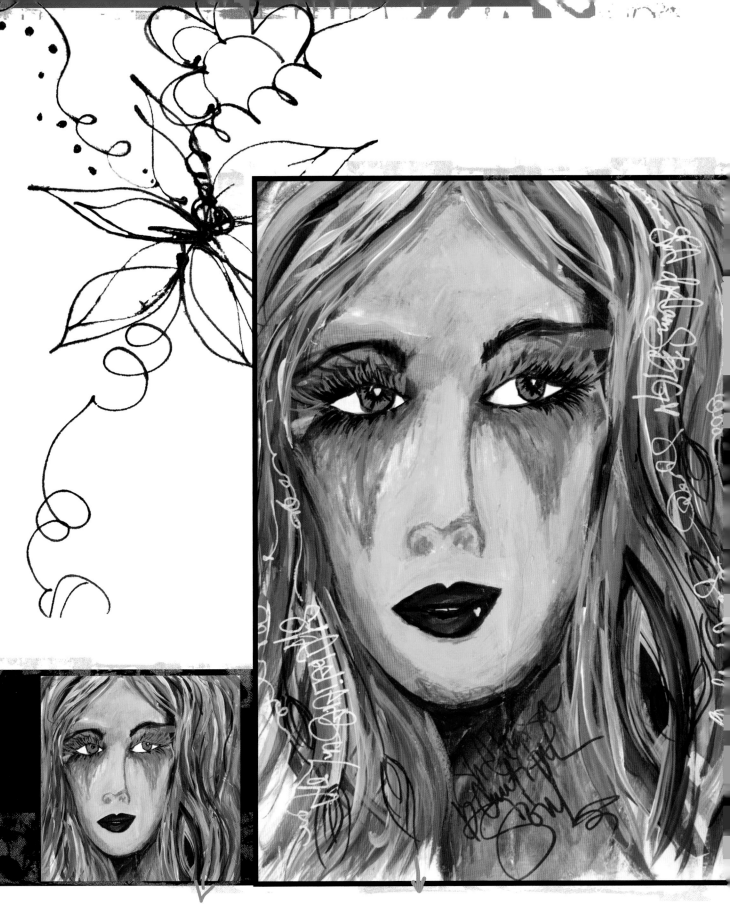

7 Lighten up the painting by adding a brighter color to the hair, blending it with white paint. Smooth out the color of the face and add detail to the nose and skin tone.

8 Write a few phrases, scribbling and doodling with a white gel pen. Doodle hair embellishments with brush markers.

EXERCISE: FASHIONISTA BALINESE DANCER

My fashionista faces are inspired by fashion photography and my own imagination. They are stylized illustrations that combine drawing, sketching and patterns with vibrant colors and inspirations from my travels. This face was inspired by my trip to Bali and the beautiful crowned dancers I saw there.

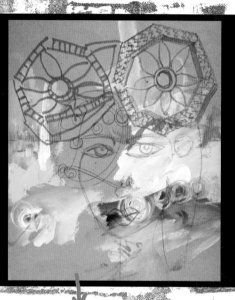

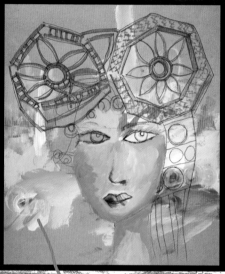

1 Create a background by fingerpainting with acrylic paints on a brown paper grocery bag. Let it dry. Using a picture from a magazine as inspiration, quickly sketch a face about a third of the way down the page. This will leave room for you to create elaborate hair and a headdress later. The sketch doesn't need to be detailed, as you will be painting over it.

2 Mix paint colors and paint the face. I prefer to paint with primary colors and mix my own paints as I work. The base layer is a mixture of Hansa Yellow Medium with a dab of Phthalo Blue and a dab Titanium White.

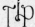

Tip

If you need help drawing, use tissue paper or transparencies to trace an image. Keep in mind, though, that the goal is to draw freehand. The more you practice this skill, the better you will be at drawing faces.

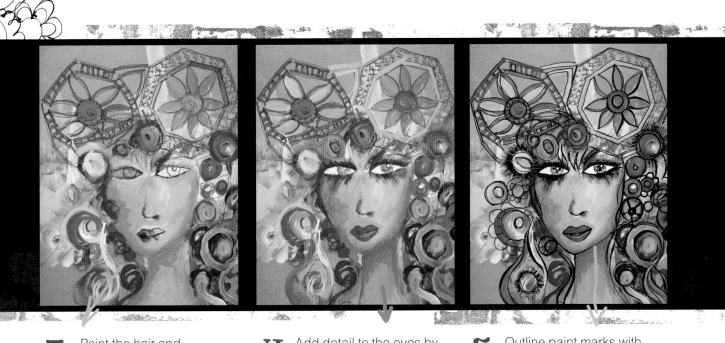

3 Paint the hair and headdress with various contrast colors.

4 Add detail to the eyes by blending colored pencils over dried paint.

5 Outline paint marks with a black oil-based paint marker. Color in the eyes and eyelashes, hair and headdress with colored pencils.

6 Add thicker black lines and details with a black oil-based paint marker. Outline the facial features and add bits of gold throughout the design with a metallic gold paint pen.

EXERCISE: GIRLIE GLAM GRAFFITI PANEL

Many of the surfaces I use for my paintings are recycled and reclaimed. I often paint on cardboard; an example of this is my graffiti panels (see page 62). I like to recycle USPS (United States Post Service) Priority mailing boxes. Paint the background, collage, doodle and color. Explore painting on this great nontraditional surface.

CREATIVE TOOLBOX

- BLACK-AND-WHITE PHOTO-COPIES OF YOUR ORIGINAL ARTWORK
- BLACK CHISEL-TIP PERMANENT MARKER
- FLOW ACRYLIC PAINT (MATISSE DERIVAN)
- GESSO
- MAILING BOX OR CARDBOARD
- SCISSORS OR AWL
- SIZE 1 OR 2 ROUND PAINTBRUSH
- SOFT PASTELS (PANPASTEL)
- WATERPROOF INDIA INK (SPEEDBALL)

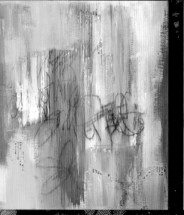
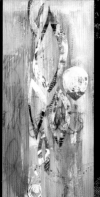
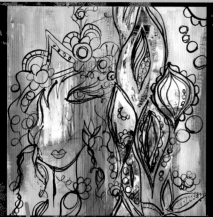

1 Tear, score and add tape to a cardboard surface. Scribble with a black chisel-tip permanent marker. Combine acrylic paint and gesso. Paint the surface of the board.

2 Cut out shapes from photocopies and collage them to the board.

3 Doodle a face and shapes with a round paintbrush and waterproof India ink.

4 Paint the face and doodles and highlight the photocopies with flow acrylic paints. Add soft pastels to even out the face color.

Tip

These panels make great art journal covers. Create two panels of similar size and stitch them together to create a cover and add pages to finish the journal.

5 Add final touches of paint and doodles to the hair and crown.

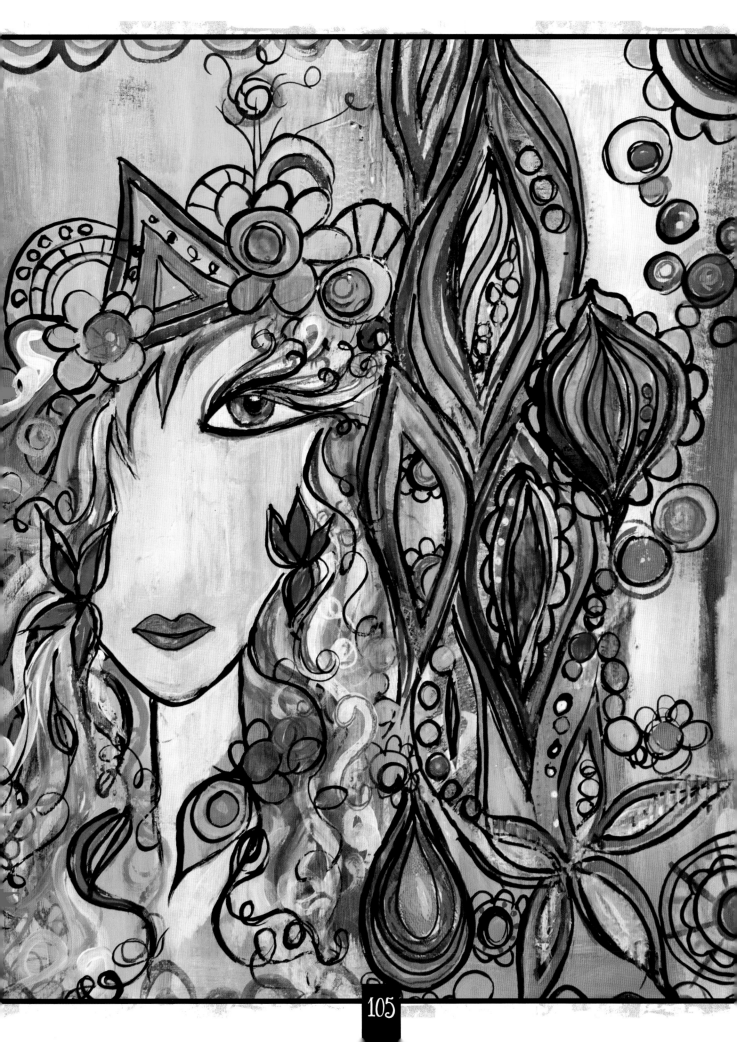

EXERCISE: DIGITALLY DOODLED FACE

Take your art to the next level by combining your hand-painted creations with a little digital twist. Exploring the digital aspect of design is a great way to enhance your art. I use a pen tablet to doodle on the computer to create precise lines and marks. Experiment with drawing on the computer!

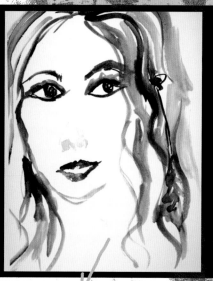

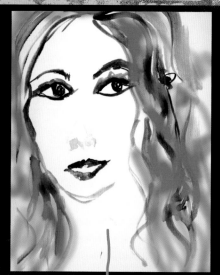

1 Open an image of a watercolor painting (such as the free digital download listed above). You will use this as your base image.

2 Create a second layer. Using a pen tablet, select the brush tool. Choose a brush with a spray paint finish and paint the hair.

106

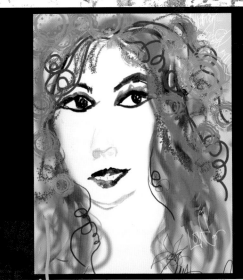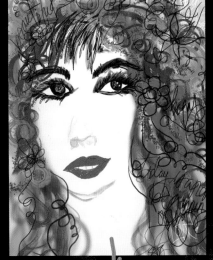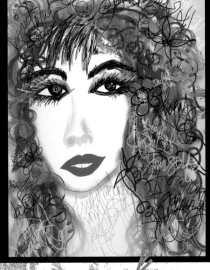

3 Create a third layer. Import a brush from the *Doodles Unleashed* digital brush kit (www.treicdesigns.com) and stamp the brush around the painting to add doodles to the hair.

4 Create a fourth layer. Change the brush size and color. Add more doodles using the brush tool. Repeat and add a few different widths and colors of hair. Draw the eyelashes with two different colors and add color to the lips.

5 Create a fifth layer. Change the brush size and color. Scribble and write words with the pen tablet. I changed the brush color and size four times to achieve varied lettering styles. Fill in the face. Add shading to the face with a brush with a soft edge.

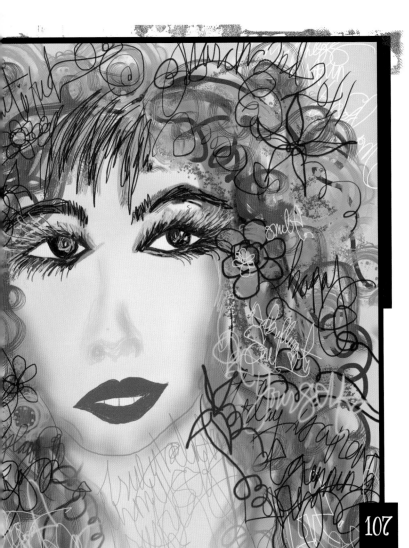

Tips

- Experiment with drawing over your own images or adding doodles to photos.

- It takes practice to master the pen tablet, so don't give up. It's just like using a paintbrush with a little twist. The nice thing is that you can always UNDO your marks.

- Practice writing by changing your brush sizes to see what works best for you. When you write on the tablet, make the same movements that you would make using a real pen.

- Download the *Doodles Unleashed* digital kit at www.treicdesigns.com.

EXERCISE: PHOTOCOPY COLLAGE FACE

Now it's time to work with photocopy collage. Make black-and-white laser photocopies of your original artwork and cut out pieces to repurpose. You've experimented with making marks and other elements; now it's time to put them all together in your own unique fashion. Look for the doodle in your background collage and venture into making marks with a small paintbrush.

CREATIVE TOOLBOX

ACRYLIC PAINT

BASSWOOD CANVAS (WALNUT HOLLOW)

BLACK-AND-WHITE PHOTOCOPIES

BLACK PEN (COPIC MULTILINER)

COLLAGE PAUGE MATTE

COLORED PENCILS (PRISMACOLOR)

COLORED PERMANENT MARKERS

GESSO

ROUND PAINTBRUSHES

SCISSORS

TISSUE PAPER

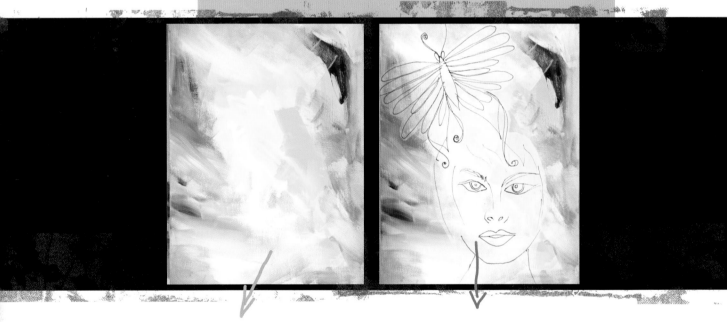

1 Paint a basswood canvas with a mixture of acrylic paint colors and white.

2 Draw a butterfly and face on tissue paper. Adhere the tissue paper to the canvas with Collage Pauge Matte medium. Brush the medium over the tissue paper to seal it. Rub it lightly with your fingers to get rid of air bubbles.

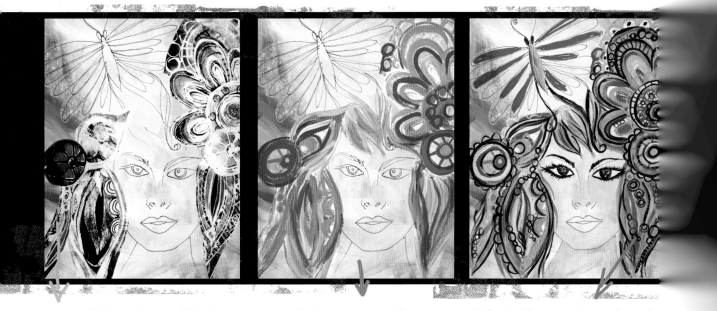

3 Collage pieces of black-and-white photocopies to the canvas with Collage Pauge Matte.

4 Paint gesso over the photocopies to lighten the color. Paint over the top with acrylic paint.

5 Add contrasting colors of acrylic paint. Accent the doodles with an outline of darker paint. Use a very small round brush for the detail work.

6 Add final details. Color in the lips and butterfly with colored pencils and colored permanent markers. Add shading to the face by blending a darker color pencil over the black lines. Blend the colors with a white colored pencil.

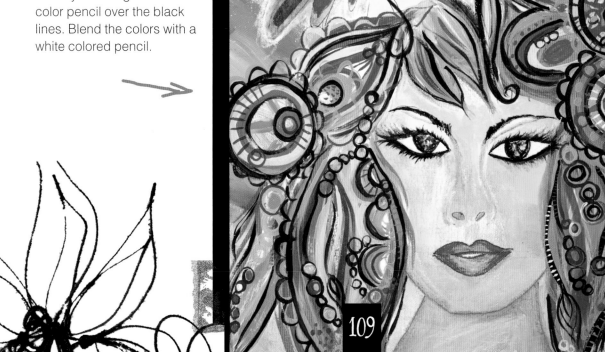

PERSONAL GRAFFITI

We all have a style of writing that defines us—a personal graffiti. My style of writing has developed from the time I was a little girl practicing with a calligraphy pen. I would sit everyday and write letters neatly on binder paper, trying to copy the samples in the book. As I grew older, my love for lettering grew, and I would practice creating my own doodling in my Pee Chee folders. My personal graffiti has developed into layers and layers of letters. I often write whatever is on my mind in my journals or as layers underneath my paintings. I write in a fast, conscious stream and let whatever I'm thinking spill onto the page. Sometimes I mix my doodles with my journaling by intertwining the words with the lines of my doodles.

Personal graffiti is an exploration of you. Delve into aspects of your creative soul by capturing unique images for a collaged self-portrait. For a week, take pictures every day of your favorite things and collect your "paper trail"—any paper ephemera that is somehow related to you, from junk mail to receipts to clothing tags. Create a collage using these elements. Journal your thoughts onto the collage to complete your personal graffiti self-portrait.

CREATIVE EXERCISE
PERSONAL GRAFFITI

As you journal, ask yourself the following questions:
- What excites you?
- What or who inspires you?
- What are your favorite colors?
- Where do you go for inspiration?
- Who are your favorite artists and musicians?

This is an inspiration board I created from magazine images. I used these images to inspire my drawings on the surface of a hand-painted dress. Create an inspiration board of images, colors, marks and letters. Use these to inspire your artwork.

INCORPORATING JOURNALING INTO YOUR ART

My words are often intertwined with my drawings and doodles. My thoughts and ideas flow from the pen dipped in calligraphy ink and swirl onto the page to create my personal graffiti. Every year, I visually brainstorm a list of the things I want to accomplish personally and professionally.

Spend some time pondering these questions: What do you want to accomplish? What do you desire? What changes do you need to make? Color a piece of bristol vellum with brushmarks of paint. Write over the painted background to create interesting marks and shapes with your lines. Overlap words. Create layers of writing with a dip pen and India ink. Alter the painting by adding more marks with markers, gel pens and colored pencils. Be free with your words and lines.

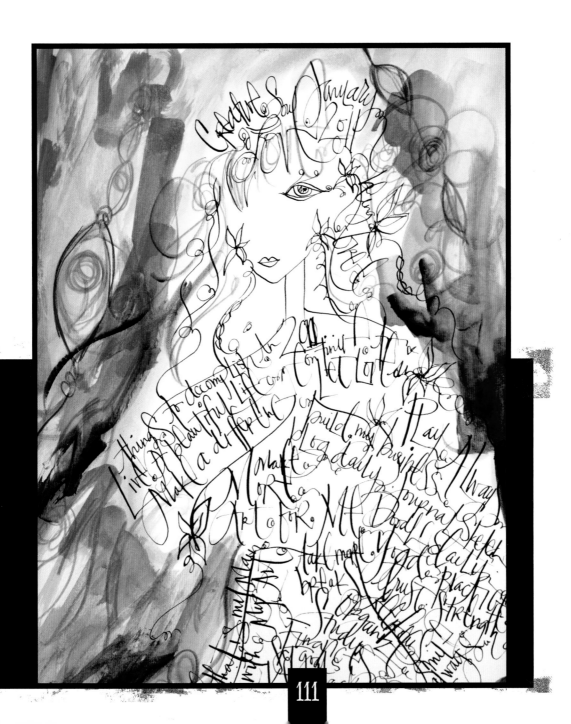

EXERCISE: GRAFFITI VISUAL JOURNAL PAGE

Explore combining your writing and collage to create a mixed-media journal page with layers of handmade stamps, paints and doodles. Blend your stylized faces, unique marks and personal graffiti, and enjoy the process of being free and mixing your favorite techniques!

1 Paint a piece of 140 lb. (300gsm) mixed-media paper with yellow flow acrylic paint. Add a dab of green to the brush and mix the paint on the edges of the paper. Cut a rectangle shape out of cardboard and peel back the top layer of paper to reveal the corrugated center. Apply green paint to a handmade cardboard stamp and press it onto the painted background. Paint a shape of a face and body with a mixture of green, blue and white. Let it dry.

2 Tear a piece of graffiti tissue paper. Brush Collage Pauge over the painted background, working on small sections at a time. Press the graffiti tissue paper onto the Collage Pauge. Apply another layer of adhesive over the top of the tissue paper. Let it dry.

CREATIVE TOOLBOX

1" (2.5CM) FOAM BRUSH

140 LB. (300GSM) MIXED-MEDIA PAPER (STRATHMORE)

COLLAGE PAUGE

COLORED PENCILS (PRISMACOLOR)

DIP PEN (BRAUSE FINGER NIB)

FLOW ACRYLIC PAINT (MATISSE DERIVAN)

GRAFFITI TISSUE PAPER (SEE PAGE 48)

HANDMADE STAMP FROM CORRUGATED CARDBOARD

SOFT PASTELS (PANPASTEL)

SPONGE APPLICATOR

WATERPROOF INDIA INK (SPEEDBALL)

3 Draw a girlie glam face with a dip pen and waterproof India ink. Answer the journal prompt "Where does my path lead?" Write words with a dip pen, intertwining them with the face.

4 Begin to add color to the face with soft pastels and a sponge applicator.

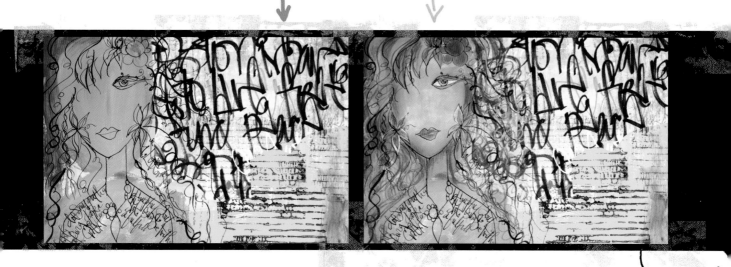

5 Draw doodles into the hair with two colored pencils. Add more color definition in the shirt and flowers.

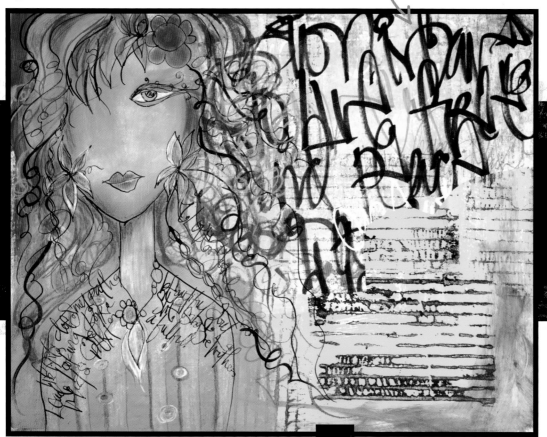

HAND-DRAWN LETTERS

From A to Z, employ different mixed-media jumpstarts and doodling techniques to create an exemplar of letters. Leverage your art by taking photos, digitally altering your letters or printing and collaging them into all of your mixed-media creations.

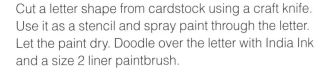

Cut a letter shape from cardstock using a craft knife. Use it as a stencil and spray paint through the letter. Let the paint dry. Doodle over the letter with India Ink and a size 2 liner paintbrush.

Cut a letter shape from a duct tape sheet and adhere it to brown craft paper. Outline the tape letter with a black permanent pen. Fill in the outline with doodles, shapes and patterns. Continue to draw the patterns over the duct tape.

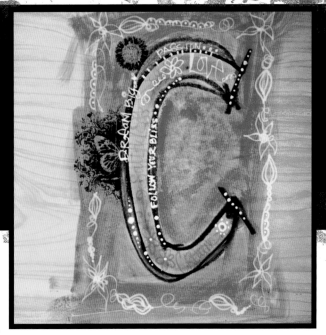

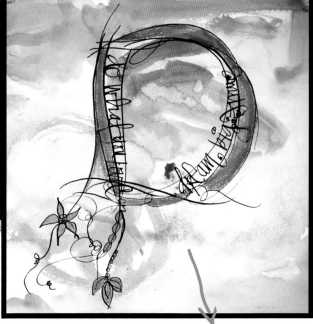

Draw the outline of a letter on wood veneer paper with a black solid paint marker. Adhere Creative Imaginations foil shapes. Paint red watercolor paint over the foil and around the letter. Let the paint dry. Fill in the letter shape with soft pastels. Write words and doodles with gel pens.

Create a background with random watercolors using the wet-on-wet technique. Let it dry. Write a letter with a dip pen and India ink. Let it dry. Fill in a portion of the letter by blending art markers and metallic gel pens.

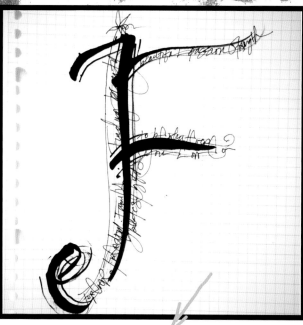

Draw a letter onto a craft envelope with a pipette filled with India ink. Let it dry. Fill in the letter with Copic markers and blend the colors. Add doodled lines with a Copic brush pen.

Draw the outline of a letter onto graph paper with a handmade skewer tool (see page 8) dipped in India ink. Write words in between the lines of the letter shape with a black Copic Multiliner .03 pen.

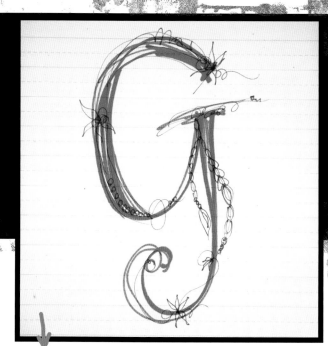

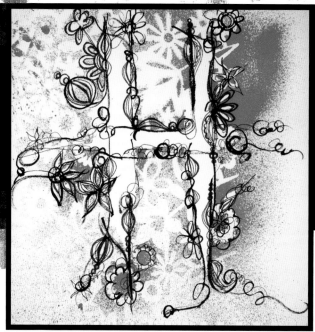

Draw the outline of a letter with a fuchsia fine-tip permanent marker. Fill in the letter with a red chisel-tip permanent marker. Draw flourishes with a turquoise fine-tip permanent marker.

Form a letter with masking tape on a piece of Strathmore mixed-media paper. Place a piece of lasercut floral cardstock over the surface and spray the entire piece with LuminArte Radiant Rain spray. Let it dry. Remove the tape and cardstock. Draw the letter with a Pentel brush pen and doodle around the letter with a fine-tip permanent marker.

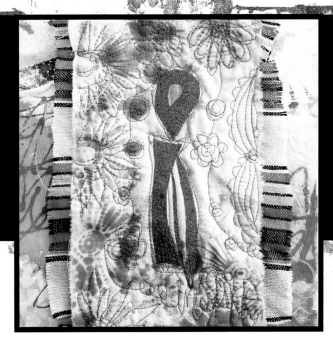

Cut a letter shape from a Tulip Fashion glitter sheet and iron it onto a piece of painted muslin fabric. Using a sewing machine equipped with a darning or embroidery foot, freemotion doodle over the top of the letter.

Write a letter on scrapbook paper with a permanent metallic silver marker. Draw over the letter with a variety of gel pens.

Draw the outline of a letter on bristol vellum with Tulip SLICK dimensional fabric paint. Let the paint dry. Write inside the letter shape with a black Copic Multiliner 0.3 pen. Fill in the letter with two colors of watercolor washes.

Adhere Hambly rub-on letters to black cardstock. Draw the shape of a letter around the rub-ons with a white correction fluid pen. Use a white gel pen to draw thinner lines.

Draw a letter on painted paper with a Copic Multiliner pen. Adhere different flourish rub-ons to embellish the letter. Fill in the letter with Prismacolor colored pencils and blend them with a white colored pencil.

Draw a letter on Strathmore mixed-media paper using Collage Pauge in a fine-tip applicator squeeze bottle. Let it dry. Paint a watercolor wash over the letter. Let it dry. Doodle and scribble words over the paint with gel pens.

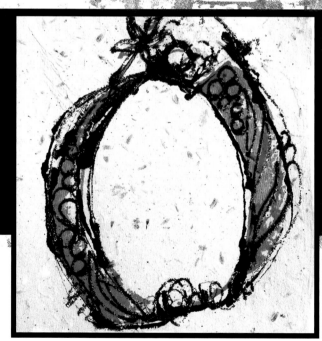

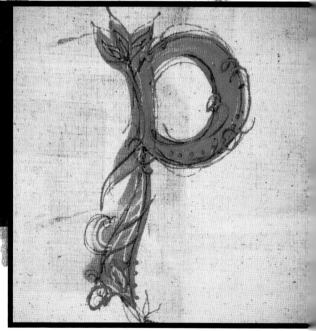

Draw a letter on handmade paper with a Copic wide marker. Outline the letter with India ink in a plastic pipette. Let it dry. Draw lines over the letter with Tulip SLICK dimensional fabric paint. Sprinkle ultrafine black glitter over the dimensional paint while it is still wet.

Draw a letter shape backwards onto a piece of self-adhesive craft foam to make a stamp. Cut out the stamp and roll paint onto it with a soft rubber brayer. Stamp it onto osnaburg fabric and roll a clean brayer over it to transfer the stamp print onto the fabric. Let it dry. Outline and doodle around the painted letter with Tulip SLICK dimensional fabric paint.

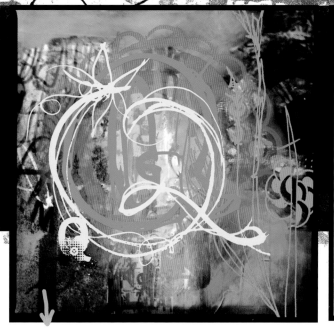

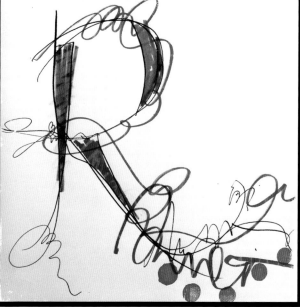

Using Adobe Photoshop, open a collage image to use as the background.

Create a new layer. Choose a font and type a letter. Change the font color.

Create another layer. Draw the letter using a pen tablet, or import a sample letter Q from www.treicdesigns.com.

Create another layer. Add marks with various brushes and stamp tools (also available from www.treicdesigns.com).

Draw the outline of a letter with a black permanent pen. Scribble color with Crayola Changeable markers. Add more lines with highlighters and dauber paint bottles.

Doodle a letter into turquoise craft sheet metal using the Walnut Hallow Creative Metal tool kit. Use various nibs to draw the design.

Draw the outline of a letter with a black Copic Multi-liner 0.5 pen. Add doodles inside the letter outline.

Paint a letter onto a mailing envelope with a Matisse Derivan liquid pencil. Let it dry. Blend two to three colors of soft pastels over the letter. Add doodles with a black permanent pen. Fill in the pattern with bright colored permanent markers.

Draw a letter onto construction paper with a handmade skewer tool dipped in sumi ink. Fill in between the letter lines with blended colored pencils. Take a photo of the letter on top of a painted background. Import the image into Adobe Photoshop. Add a layer and import a second image of scribbled writing. Change Blending Mode to Overlay and reduce the visibility of the top layer so the letterform shows through.

Draw a letter on drill cloth with a Pilot Tough Wash pen. Color the design with fabric markers.

Apply Tombo permanent two-sided adhesive to paper in the shape of a letter. Place Creative Imaginations foil sheets in two to three colors over the tape. This will cover the tape with foil. Draw outlines around the letter with Tulip SLICK dimensional fabric paint. Sprinkle glitter over the dimensional paint while it is still wet.

Draw a letter shape onto kids' storybook paper with Caran d'Ache Neocolor crayons. Spread the color with a water brush. Outline the letter with a Copic brush marker. Doodle over the letter with colored and metallic gel pens. Add accents with a white correction fluid pen.

Collage hand-painted resist paper and color photocopies into the shape of a letter with Collage Pauge. Let it dry. Add doodled patterns around the outside of the letter with Sakura Pigma Sensei pens.

GOODIES

Be inspired by my artwork. Use these images to jumpstart your doodles. Create artist trading cards and collage sheets, enlarge the images and draw and paint over them, or print them on one-sheet label paper to create stickers. Happy creating!

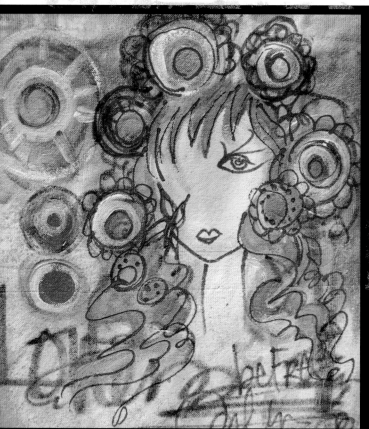

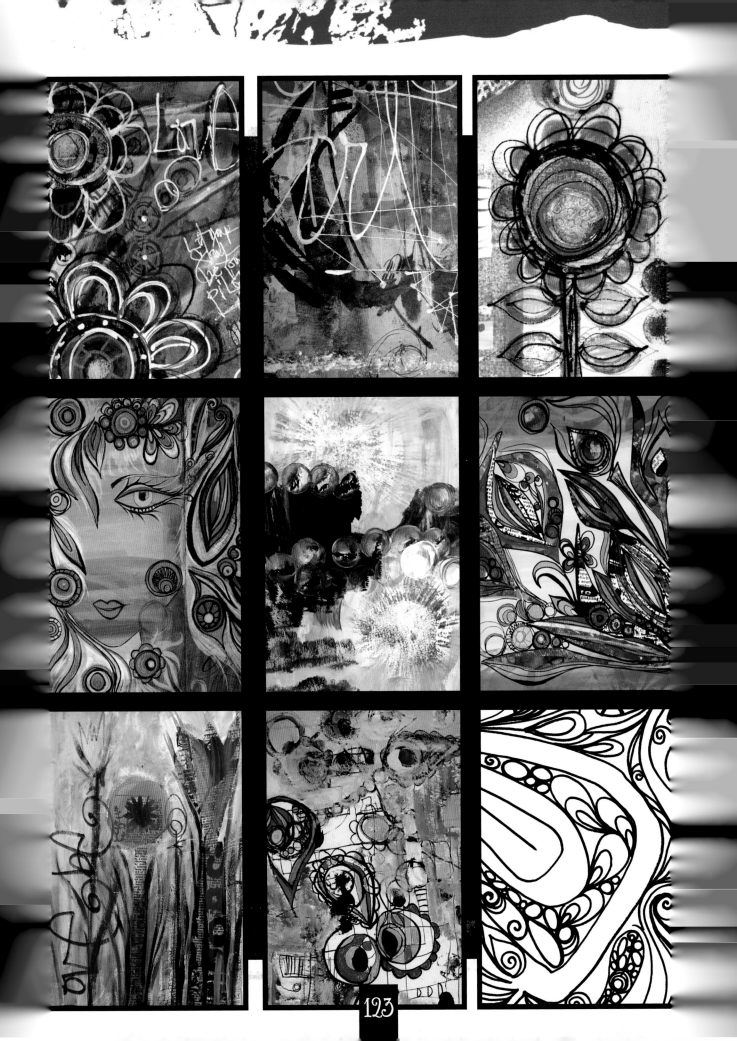

RESOURCES

Find digital art journaling kits, including brushes, overlays, fonts and more at www.treicdesigns.com.

Visit the book website at www.doodlesunleashed.com.

Take an online mixed-media workshop with me at creativityunleashed.ning.com

BE INSPIRED & CONNECT WITH ME!

MY BLOG: HTTP://KOLLAJ.TYPEPAD.COM
WWW.FACEBOOK.COM/TREICDESIGNS
WWW.TWITTER.COM/TREICDESIGNS
WWW.FLICKR.COM/TREICDESIGNS
WWW.PINTEREST.COM/TREICDESIGNS
WWW.YOUTUBE.COM/TREICDESIGNS
TRACIBAUTISTA.ETSY.COM

WHERE TO FIND MY FAVORITE SUPPLIES

iLoveToCreate: www.ilovetocreate.com
Collage Pauge, Tulip SLICK dimensional fabric paint, Tulip fabric sprays

Copic: copicmarker.com
markers and pens

Matisse Derivan: www.derivan.com.au
Flow Formula acrylic paint

Sakura: www.sakuraofamerica.com
Gelly Roll pens and other markers

Strathmore: www.strathmoreartist.com
papers

Tangerine: www.elevenmorningstangerine.com
German glass glitter, vintage flowers and inspiration galore for your mixed-media projects

VISIT MY LOVELY ARTIST FRIENDS FOR CREATIVE INSPIRATION

Autumn Durald: www.autumndurald.com

Karen Michel: www.karenmichel.com

Susan Lenart Kazmer: slkartmechanic.com

Lisa Engelbrecht: www.lisaengelbrecht.com

Micheal deMeng: www.michaeldemeng.com

Ruth Rae: www.ruthrae.com

Kathy Cano-Murillo: www.craftychica.com

Keely Benkey: straystitches.typepad.com

Misty Mawn: mistymawn.typepad.com

Sherill Kahn: www.impressmenow.com

Teesha Moore: www.teeshamoore.com

Tracy Moore: www.zettiology.com

Christine Adolph: christineadolph.typepad.com

Alisa Burke: www.alisaburke.com

Jennifer Perkins: naughtysecretaryclub.blogspot.com

Vickie Howell: www.vickiehowell.com

FOR A DETAILED LIST OF MY
FAVORITE CREATIVE SUPPLIES, VISIT
WWW.DOODLESUNLEASHED.COM

INDEX

About the Author

After a successful career climbing the corporate ladder, marketing high-tech start-ups and brands like IBM and Animal Planet, Traci left Silicon Valley to pursue her passion for art. 2011 marks the ten-year anniversary of launching her creative business endeavor, treiC designs. Prior to becoming a full-time artist, she worked as a graphic designer, event planner, marketing director, professional cheerleader, elementary art teacher, fashion designer and Web designer, just to name a few. Experiences that she gained through these positions, coupled with her innate drive to explore and create without boundaries, are what contribute to her success as a mixed-media artist. She teaches mixed-media workshops worldwide on handmade books, art journaling, collage, art marketing and surface design.

Traci is a mixed-media artist, designer and author of the best-selling book, *Collage Unleashed.* Her art has been featured in over fifty art and mixed-media publications, numerous blogs, and HGTV and DIY networks. She designs licensed product lines, Collage Pauge adhesive and {kolLAJ} paper crafts. Follow her creative musings at www.treicdesigns.com, or at her blog, creativityUNLEASHED, at http://kollaj.typepad.com.

Dedication

To Marley and Aspen: May you grow to know the beauty of being a creative soul. DREAM BIG! Love, Auntie Boo Boo.

In loving memory of my "little munchkin," Freedom. You will forever be in my heart. XOXO

Much Love and Many Thanks to . . .

. . . Papa, Mama and Dude: I am so grateful for your support and encouragement to follow my dreams and do what I love. Thank you. I love you.

. . . Tyler: You teach me to enjoy the simple pleasures in life. Thank you, love.

. . . Autumn Durald . . . Tu . . . your creative spirit shines through your beautiful photography. Thank you for my author portrait. XO

. . . the many artists who have crossed my path throughout the years. Thank you for sharing in my creative journey!

ACKNOWLEDGEMENTS

Special thanks to the following people and companies for their support:

Ate Jacks Davos

Larissa Tomanek-Willis

Mikey and Tal Vincent of
 Michael Vincent Photography

Alyson Dias

Valerie Marderosian

Larry Duncan

The creative team at iLoveToCreate

Julia Reed-Santos

Sakura of America

PanPastel

Allison Kreft Abad

Walnut Hollow

Hambly Studios

Creative Imaginations

Matisse Derivan

Ice Resin

Strathmore Artist Papers

C&T Publishing

Roc-Lon Fabrics

Copic Markers

Stencil Girl Products by Mary Beth Shaw

F+W Media: Tonia Davenport, Rachel Scheller
 and Christine Doyle

DISTRIBUTED IN AUSTRALIA BY CAPRICORN LINK
P.O. Box 704, S. Windsor NSW, 2756 Australia
Tel: (02) 4577-3555

SRN: Y2997
ISBN-13: 978-1-4403-1089-8

media

www.fwmedia.com

16 15 14 13 12 5 4 3 2 1

DISTRIBUTED IN CANADA BY FRASER DIRECT
100 Armstrong Avenue
Georgetown, ON, Canada L7G 5S4
Tel: (905) 877-4411

DISTRIBUTED IN THE U.K. AND EUROPE BY F&W MEDIA INTERNATIONAL
Brunel House, Newton Abbot, Devon, TQ12 4PU, England
Tel: (+44) 1626 323200, Fax: (+44) 1626 323319
Email: enquiries@fwmedia.com

EDITOR: RACHEL SCHELLER
DESIGNER: KELLY O'DELL
PRODUCTION COORDINATOR: GREG NOCK

METRIC CONVERSION CHART

TO CONVERT	TO	MULTIPLY BY
INCHES	CENTIMETERS	2.54
CENTIMETERS	INCHES	0.4
FEET	CENTIMETERS	30.5
CENTIMETERS	FEET	0.03
YARDS	METERS	0.9
METERS	YARDS	1.1

DOWNLOAD MORE DOODLING GOODIES!

Ready for more doodle-y goodness?

Download bonus backgrounds and design elements in Traci Bautista's signature style to scan, copy and collage into mixed-media pieces or your art journal. You can download for FREE at:

CREATEMIXEDMEDIA.COM/DOODLES-GOODIES

create mixed media

THE ONLINE COMMUNITY FOR MIXED-MEDIA ARTISTS

- techniques
- projects
- e-books
- artist profiles
- book reviews

For inspiration delivered to your inbox and artists' giveaways, sign up for our e-mail newsletter.

Follow us on Twitter and Facebook!

 @cMixedMedia

 facebook.com/CreateMixedMedia.com

 GET YOUR FAVORITE NORTH LIGHT BOOKS AT SHOPMIXEDMEDIA.COM

NORTH LIGHT BOOKS